HIDDEN
HISTORY
of
ARLINGTON
COUNTY

HIDDEN
HISTORY
of
ARLINGTON
COUNTY

Charlie Clark

THE
History
PRESS

Published by The History Press
Charleston, SC
www.historypress.net

Front cover: Arlington County Public Library.
Back cover, top: Woman's Club of Arlington; *bottom*: Burger family via Eleanor Lee
Templeman.

First published 2017

Manufactured in the United States

ISBN 9781625859235

Library of Congress Control Number: 2017934950

This one's for three high-impact Arlington teachers: Harry Tuell (Yorktown High School), who set me free in journalism; Jacqueline Jeffress Guter (Williamsburg Junior High), whose help with French broadened my horizons; and Betty Ann Armstrong (fifth and sixth grade at James Madison Elementary), who bequeathed me the basics.

CONTENTS

Contents

INTRODUCTION

Where does a community's identity come from? And how do forces—internal and external—affect that identity over time?

At 26.5 square miles, Arlington is the smallest, most densely populated county in the United States. Its destiny has been driven by its geographic proximity to Washington, D.C., and—very important—by the fact that most Potomac River crossings begin in the county.

Initially part of a large land grant to Lord Fairfax before the Revolutionary War, what is now Arlington was ceded to help form the new federal government seat by the Commonwealth of Virginia in 1790. It remained a part of the District of Columbia until 1847, when Congress retroceded it back to the commonwealth.

As the Civil War loomed, Arlington (then Alexandria County), foreshadowing its modern role within Virginia, did not join the rest of the commonwealth in supporting secession. Union forts ringed much of the periphery of the county. By the late 1890s, trollies linked Washington, D.C., and Ballston, creating a turn-of-the-century company town—the company being the federal government.

In 1920, Alexandria County became Arlington County, a name drawn from the Arlington Plantation along the Potomac River and Arlington House, both of which took their names from English entities via Virginia's Eastern Shore (as author Charlie Clark will explain). To this day, Arlington House is the centerpiece of the county's seal. In a perhaps apocryphal story, the 1920 name change is linked to a misunderstanding surrounding

a military parade planned to celebrate the end of World War I. The event was supposed to include a flyover by aircraft at Fort Myer, but the pilots buzzed Old Town Alexandria instead. That was it for our community bigwigs—time for a new name!

Until the 1940s, Arlington moseyed along like many southern towns. Main streets like Columbia Pike, Wilson Boulevard and Lee Highway offered shopping and a bit of dining. Schools—black and white—served children and teenagers. Black and white neighborhoods were well established, and churches of many faiths were scattered throughout the county. A number of longtime Arlington families of both races led their neighborhoods. Arlington's overall nature was residential and subsidiary to the big capital city across the river.

But the arrival of World War II changed that. Arlington greeted an influx of well-educated, determined Americans and their families, all drawn to President Franklin Roosevelt, his policies and government service. The feds looked no farther than Arlington as the best location to provide an unprecedented amount of new "affordable" housing, constructing the first such development at Colonial Village above Rosslyn. It was followed soon by Fairlington on the county's southern border and Arlington Village on Columbia Pike.

These new neighbors, along with many longtime African American families, are the roots of the modern era. They believed in excellent public education, using research to understand tough problems and planning, planning, planning with the community to achieve the shared vision of Arlington as a "great place to live, work and raise a family."

Policy debate at the neighborhood and countywide level was a hallmark of these midcentury years. Arlington's stay-at-home, college-educated moms functioned as an underappreciated think tank throughout this era. Both the League of Women Voters and the local chapter of the American Association of University Women studied and debated numerous public policy options. The Committee of 100 emerged as an educational forum for many of the hottest topics of the day. Arlingtonians for a Better County was formed to allow federal employees subject to Hatch Act limitations on political activity the opportunity to participate in nonpartisan electoral politics at the county board level.

As a result, in the 1950s, Arlington became the first Virginia community to move to integrate its public schools. For this stand on principles, Arlingtonians lost their capacity to elect school board members for nearly forty years. One of the lead attorneys for the historic "one man, one vote"

case served on the Arlington County Board. And the seeds of what we today call "transit-oriented development" came as a positive policy response to the community's fears that Arlington would become northern Virginia's parking lot. After much debate, the newly proposed Metro was located in the heart of Arlington with planned development rather than on an interstate highway median.

In the second half of the twentieth century, Arlington's public schools experienced two waves of change. In each case, the community brought creativity to bear on our version of national problems. In the late 1960s and early '70s, as student unrest roiled the country, the Arlington School Board created three countywide schools: Drew Model School in the African American community of Nauck; Woodlawn (later H-B Woodlawn), affectionately known as "Hippie High," with its open schedule and student-directed learning; and Page Elementary, a back-to-basics, one-teacher, one-classroom response to open schools.

In the early 1990s, faced with rapid increases in student enrollment and language diversity, as well as transit-development tax revenue growth, the community rolled up its sleeves to address diversity, crowding and educational quality. The solution, after a year of study, was a unique marriage of neighborhood schools and public school choice in new, renovated and expanded buildings coupled with a concerted focus on closing achievement gaps based on clear educational standards. The result both times? New businesses and new families joined the community.

As in most communities, political control zigged and zagged between conservatives and progressives. Regardless of party, elected leaders across the spectrum generally supported the community-developed vision and goals.

Now, in the twenty-first century, most Internet searches for Arlington County bring up accolades from various national groups for everything from affordable housing to civic engagement to smart growth and planning. These commendations regularly put Arlington in the top 1 percent of places to live in America. This reputation wasn't accidental; it's the result of more than fifty years of thoughtfulness about our regional position and broad leadership that sought to build a vibrant place for everyone.

Obviously, the journey isn't complete. In 2015, forty years after the community decided on its "bull's-eye around the Metro station" redevelopment strategy, that vision was essentially achieved. The results were astonishingly close to what was envisioned in terms of residents, commercial and retail square footage and tax revenue. Issues looming large for the regional economy include the following: the right amount of

density; the best way to attract new commercial activity; redevelopment of Columbia Pike and Lee Highway; expansion of transit offerings; a student population that is likely to exceed that of the baby-boom years; and housing affordability that matches the wages paid by Arlington's service industries and white-collar jobs.

We've got a long tradition of using our greatest strength—our residents and their creative ideas and capacities—to solve tough problems. It's Arlington's journey from rural Alexandria to a vibrant, diverse, transit-oriented urban place that Charlie Clark invites the reader to explore through his vivid, sometimes offbeat vignettes, anecdotes and personality profiles. Enjoy as you learn!

MARY HUGHES HYNES
Former chair of the Arlington County Board
and the Arlington School Board

FOREWORD

The mission of the Center for Local History at the Arlington Public Library is to "collect, preserve and share" the history of Arlington. Charlie Clark, who writes extensively on all things Arlington, is a familiar face at the center.

Charlie may come in with questions regarding an individual, an event, an address or a general location, any of which may be the starting point for an article he is planning to write. Perhaps he would like to know the history of a particular location. This might lead him to our collection of fire insurance maps, city directories or old telephone books. A recent inquiry of his about a serious crime committed years ago was answered with numerous articles from local newspapers. Another time, our oral history collection might be a good source for some community folklore he has heard and wants to verify.

Arlington has a unique history. In 1801, it was appropriated by Congress to become part of the District of Columbia, but it was returned (retroceded) to the state some forty-five years later. It was a rural county for many years, with a particularly large growth spurt occurring during World War II, when many people arrived to work for the federal government. Even so, the county's last dairy farm did not cease operation until 1955.

If there is one phrase that best describes Arlington and its citizens, it is "civic engagement." The county has had a long history of public discourse and activism. The Arlington Civic Federation celebrated its 100th anniversary in 2016, and the Committee of 100, meeting monthly, has been a forum for discussion and education on a variety of topics since its founding in 1954.

In recent years, Arlington has become increasingly diverse. In the 1970s, Clarendon developed into a shopping area for refugees who had left Vietnam around the time of the fall of Saigon. Today, Arlington continues to be a place that welcomes immigrants. In 2015, students in the Arlington Public Schools came from more than 120 countries and spoke almost that many languages.

Arlington has also become known for "smart growth," a theory of land development that seeks to ensure that development is directed in an intentional and comprehensive way. Since the 1960s, the government has had a policy of encouraging mixed-use and pedestrian- and transit-oriented development. It received the Environmental Protection Agency's National Award for Smart Growth Achievement for "Overall Excellence in Smart Growth" in 2002.

For anyone interested in researching topics related to Arlington and its history, the Center for Local History is rich in resources. A large oral history collection, vertical files on numerous subjects related to Arlington, aerial photos, local newspapers and genealogical materials are just a few of its resources. The center also includes a community archive that collects and preserves the records and documents of the citizens, organizations and businesses of Arlington.

Writers of local history need to be good detectives. Charlie has a way of discovering the little-known stories about this community and writing about them in an entertaining and educational way. He possesses what is possibly the most important attribute of a good writer: curiosity. Arlington is fortunate to be the focus of much of that curiosity!

JUDY KNUDSEN
Manager for the Center for Local History
at the Arlington County Central Library

ACKNOWLEDGEMENTS

Thanks go to the following individuals: Ellen McCallister Clark (lover and proofreader), Susannah Clark, Elizabeth Clark McKenzie, Tom Clark, Andrew Ratliff, Tony Awad, Jane Martin, Samantha Hunter, Rick Bethem, Tom Varner, Iona Dillard, Eric and Linda Christenson, Loki Mulholland, Joan Mulholland, Casey Robinson, Sandy Newton, Joanie Matthews, Jeanne Franklin, Greg Paspatis, Susan McBride, Peggy Page, John Stanton, Herman Obermeyer, Rick Schumann, George Dodge, Mary Curtius, Diane Sun, Susan Kalish, Catherine Matthews, Eric Dobson, Carole Herrick, Linda Erdos, Frank Bellavia, George Laumann, Tony Ditoto, Johnathan Thomas, Joan Hitt, Conchita Mitchell, Gerry Laporte, Tom Dickenson and Karl VanNewkirk.

AUTHOR'S CONFESSION

A note on my definition of "hidden." If I were Arlington's omniscient narrator, I could pen a blockbuster packed with "fly on the wall" espionage drama, details of citizens' sex lives and proof of official corruption. But it would be wrong.

What I do present is an "infill" set of essays designed to dovetail with the storied basic history of our northern Virginia suburb of the nation's capital. In producing my weekly "Our Man in Arlington" column for the *Falls Church News-Press*, I come across many juicy factoids that leap out as being not literally hidden, but little known. To find the tidbits, I sometimes had to dig. I wouldn't have found them all in the texts of the eighty historical signs that dot our county's streets and landmarks (though I'd wager that those signs are not sufficiently read). Some that I found did not inspire a full essay but merited presentation as stand-alone squibs. In reading a 1955 magazine essay by Arlington-based state delegate Kathryn Stone, I stumbled on an astonishing fact: When the new Wakefield school combining junior and senior high students scheduled a PTA meeting in 1954, 2,000 parents showed up!

Some finds were personal. I inherited a 1943 photo of my parents when they were dating during World War II. I knew they'd lived in Arlington but didn't know the street. I took the black-and-white shot with its house number (603) and drove into South Arlington. Magically, when I emerged from Sixth Street onto Walter Reed Drive, I stared across a courtyard and immediately recognized the exact entranceway of the Fillmore Gardens apartments, still

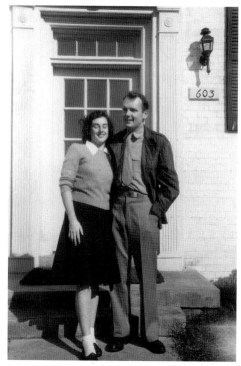

Left: The author's parents in 1943. *Clark family photo*.

Below: The Twin Bridges Marriott. *Marriott*.

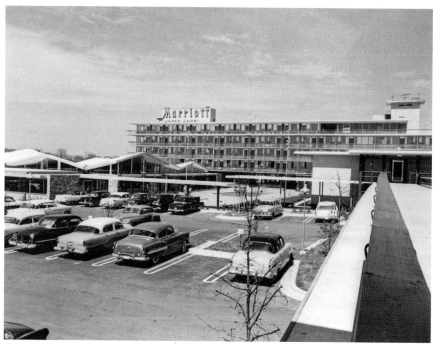

intact after seventy years. (I knocked on the door and wowed a bewildered resident with my time-travel find.)

In my reporting, I get to glimpse some amazing private documents. The Washington Golf and Country Club (founded 1894), which boasts five U.S. presidents as past members, has a 1920s directory listing Woodrow Wilson with this address: the White House.

A formerly hidden story can now be told. Famed Watergate reporter Bob Woodward of the *Washington Post* revealed in 2005 that he used to meet his highly placed source, nicknamed "Deep Throat," in a parking garage in Arlington's Rosslyn neighborhood. Residents demanded that a historic plaque be erected at the site, and this was accomplished in 2011. The garage, however, is slated to be torn down to make way for an apartment building. Still, developer Monday Properties is preserving the historic sign on the sidewalk on North Nash Street.

The global Marriott hotel chain likes to report that its first motor hotel was in Arlington. The Twin Bridges Marriott was built in 1957 near the Fourteenth Street Bridge and the George Washington Memorial Parkway. It was torn down in 1990. But baby-boomer rock fans recall it as the site where Little Feat guitarist Lowell George met his end in 1979 from a heart attack.

Last but not least, fewer and fewer Arlington old-timers recall a time when teenagers, after getting their driver's license, ventured over to Speed Hill. It's still there, hidden off Nellie Custis Drive and hugging the Potomac along the 2700 block of North Quebec Street. Many a rookie driver as far back as the 1960s tested his (parents') speedometer on what was reputed to be the steepest hill in Arlington. I recall that at one point, worried authorities made it a one-way thoroughfare—going up. Today, it's a two-way street, lined by beautiful upscale homes, the inhabitants of which, I was recently told, call it Death Hill. May all who experience it—and all who read these essays—travel Arlington safely.

CHARLIE CLARK

Early Arlington

The Original Arlington

"Welcome to the Eastern Shore of Virginia," read the roadside greeting in Northampton County.

My wife and I used a vacation in June 2016 for a pilgrimage to the original Arlington Plantation, from which our fair suburban county drew its name. The site, off the tourist circuit, is reached by driving north from Norfolk via the miraculous Chesapeake Bay Bridge-Tunnel or by heading south from Chincoteague down Highway 13.

In its own quiet way, the site of the 346-year-old home known as Arlington Plantation is a near-forgotten mother lode in the history of our county, state and nation. Once Virginia's finest residence, it was briefly the Old Dominion's capital and is the original source of the wealth married into by George Washington.

Mystery hovers around the origins of our county's name. The basics are clear: George Washington Parke Custis, the grandson of Martha Washington raised at Mount Vernon, inherited the 1,100-acre tract of land on the upper Potomac from his father, John Parke Custis. Beginning in 1802, he built the home he called Arlington House, after his ancestral home on the Eastern Shore.

That Chesapeake mansion, built by John Custis II (1628–1696), was likely named for his father's English home in Gloucester, in the Cotswolds, west of

London, called Arlington. (A competing tale says Custis was honoring Henry Bennet, Earl of Arlington.) Either way, "Virginia's finest 17th-century mansion rose from planting tobacco in well-drained sandy loam and factoring shipments to Europe," reads the signage.

The tomb of the ancestor of Arlington, John Custis. *Charlie Clark.*

In our era, Arlington Plantation merits only a squib in tourist brochures for the Eastern Shore—a struggling region dependent on fishing. The local visitors' center gets few inquiries. A historical marker on Highway 13 reads, "Arlington on the Potomac was named for this Arlington." We turned onto Arlington Road and Custis Tombs Road and drove by cornfields, then we arrived at the labeled site of a well-manicured and marked open grass lot. Alongside it is a small parking lot and a brick enclosure next to a modern private home.

We found the pamphlet produced by the Arlington Foundation Inc., founded in 1997 and run out of nearby Eastville. It owns the historically protected property, and its archaeological digs in 1988 and 1994 uncovered ancient jugs, wine bottles and decorative masonry. "This house dwarfed other fine homes in Virginia," its sign reads. Expanding from seven to one thousand acres, the Custis property was populated as of 1677 by five slaves (later seventeen) and nine indentured servants. Despite the high Old Plantation Creek water table, the fancy home had a proper English basement.

In 1676, after the famous Bacon's Rebellion in Jamestown, Governor William Berkeley fled and took shelter with Custis, making Arlington the temporary capital.

Two tombstones contain remains of John Custis II and IV. The dimpled inscription on that of the younger—signed by its London manufacturer, "Wm. Coley Mason of Fenn Church Street"—contains the ironic claim that he died "aged 71 years, and yet lived but seven years which was the space of time he kept a bachelor's house at Arlington on the Eastern Shore of Virginia." In fact, as explained in a booklet by the late Arlington Historical Society president Sherman Pratt, this statement was a dig at Custis's wife, Frances. Their relationship was so icy that they communicated only through servants. Going to hell, Custis once told her, is "better than living in Arlington with you."

Father of Our Country in Arlington

George Washington drank here. From a spring. In the 1780s. In Arlington, on the Moses Ball land grant property off of Carlin Springs Road. You can see it if you're willing to venture onto the property owned by Virginia Hospital Center.

I visited the site in May 2016, when I took the marvelous George Washington's Forest History Walk put on by the peripatetic volunteers at WalkArlington.

All of us have sensed that the father of our country set foot in what became Arlington's suburban environs. But here was a chance to brave the rain and devote a Saturday afternoon to see an off-the-beaten-track Washington monument on a, let's say, more intimate scale.

Our brainy guide was attorney and Revolutionary War enthusiast Kevin Vincent. He connected dots in the picture of Washington's presence after he purchased twelve hundred acres of Lord Fairfax's land on the eve of the Revolution because he needed timber out at Mount Vernon.

Our group of seven debarked from the Ball-Sellers House, the pride of the Arlington Historical Society in the Glencarlyn neighborhood. Built before 1755 by miller John Ball, it offers the county's best glimpse into the everyday lives of our eighteenth-century forebears. After Ball died in 1766 (there is no record that he met Washington), the home was sold to neighborhood namesake William Carlin, who was Washington's tailor.

The county sign down the street in front of Carlin Hall contains one error, Vincent confided, about the Ball brothers, Moses and John. There's no evidence that they were related to Washington via the first president's mother, Mary Ball, though they hailed from the same parts of Virginia, he said.

In an entry from May 1786, Washington wrote, "When I returned home I found Moses Ball, his son John Ball and William Carlin here, the first having his effects under execution wanted to borrow money to redeem them. Lent him ten pounds for this purpose."

Moses owned the adjoining property, which is why it is likely that the commander of the Continental army tied his horse and sipped from Ball's spring, his injured slave Billy Lee at his side. (Those area springs would be marketed as a resort from 1872 to 1884.)

What Washington shared with Moses Ball was the need to use a well-known oak tree as a reference point in his survey. That tree was felled by a storm in 1898; a stump survives on exhibit in the Glencarlyn Branch Library.

Fading marker of the site of the survey tree used by George Washington. *Charlie Clark.*

To glimpse the site of that famous tree, we hiked the woods of the Long Branch Nature Center. "There are few trees from the eighteenth century because they were cut down during the Civil War," Vincent explained. "But they're starting to grow back to look like they did when George Washington bought here."

We arrived at our destination—Arlington soil that we know Washington once trod. It's a hundred yards north of where Washington's property began and extended through Shirlington. (It would later include the Columbia Pike mill for Arlington House built by George Washington Parke Custis.) What you see is a pockmarked pillar—to which passersby are oblivious—marking the site of the survey tree. There is no plaque, Vincent said. The text Vincent once wrote disappeared.

ONCE ARLINGTON'S BEST VIEW

When you alight at Reagan National Airport, you're likely in a travel-fixated hurry. It might not dawn on you to slow down and stroll to the historic Abingdon Plantation. The airport authority and specialists from the Arlington Historical Society have created an easy and well-marked walk from the Metro stop through the parking garage.

You should take a contemplative break and visit one of our county's historical gems.

Abingdon has been regarded as the oldest house in Arlington, built before 1741 by Gerard Alexander of the Scottish-bred landowning family who are the city's namesakes. High on hills overlooking the Potomac and Old Town Alexandria, this prime property in the area called Gravelly Point would become the birthplace of George Washington's step-granddaughter Eleanor

Parke "Nelly" Custis. (In 1941, a Nelly Custis Airmen's Lounge was built near the airport's radar station.)

Abingdon under the Custises was also said to be the site of original planting of weeping willows in the United States.

Because the impressive Georgian home was destroyed by fire in 1930, what you see today are reconstructed red brick remains sketching the old home's outline. But you can envision it from benches surrounding tended plants and informative signage.

According to the exhibits, encyclopedias and Eleanor Lee Templeman's *Arlington Heritage*, the Alexanders' original house was nearly forty years old when it was purchased in 1778 by Martha Washington's son John Parke "Jacky" Custis. (George warned that Jacky overpaid for the eleven-hundred-acre tract.) After Jacky died of camp fever, his widow married the general's business associate, Dr. David Stuart, who helped plan the nation's capital. General Washington himself stayed there, and a bedroom was named for him.

The Custis who spent the least time at Abingdon was Nelly's brother George Washington Parke Custis, the builder of Arlington House who was raised at Mount Vernon. By the time he inherited thousands of acres in 1802, Abingdon had returned to the Alexanders.

The home was eventually sold to the Hunter family. General Alexander Hunter held a post in the Alexandria Customhouse and had money to renovate Abingdon. He was tight enough with President Andrew Jackson to host him there. (Other guests included presidents John Tyler and James Polk.)

During the Civil War, Abingdon was confiscated because its owners had joined the Confederacy. It was occupied by a Union regiment from New Jersey. In 1900, ownership fell to the Washington Brick Company; in 1924, it became the property of the Richmond, Fredericksburg and Potomac Railroad.

Following the 1930 fire, architects examined Abingdon to consider a restoration. They settled for a plaque by the Association for Preservation of Virginia's Antiquities. Historically accurate improvements were made by the Civilian Conservation Corps.

In 1940, Abingdon was acquired for National Airport. During planning for its expansion in the late 1980s, there was talk of paving over the site for a parking garage. Governor Doug Wilder and legislators blocked the idea, and a subsequent dig unearthed artifacts now on display in Terminal A.

Former resident Alexander Hunter II described the old Abingdon in 1904: "I doubt whether in the whole Southland there had existed a finer country

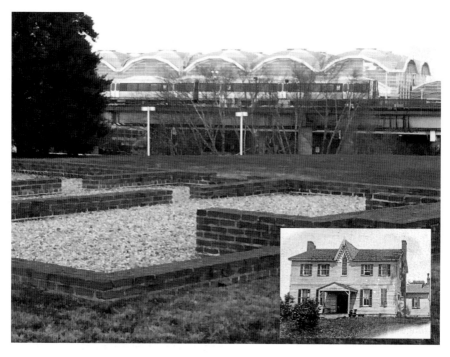

Many airport passengers miss the once-vital Abingdon Plantation and site of a house that burned in 1930. *Charlie Clark.*

seat; the house was built solidly, as if to defy time itself, with its beautiful trees, fine orchards, its terraced lawns, graveled walks leading to the river a quarter of a mile away; the splendid barns, the stables with fine horses."

Today's site offers a placid respite from the airport's holiday bustle.

TIMES A-CHANGING AT ARLINGTON HOUSE

On April 4, 2015, at Arlington House, the National Park Service put on a rich evening commemoration of the unfolding of the end of the Civil War 150 years ago. April 4 marks the day President Lincoln entered the shattered Confederate capital of Richmond—five days before the surrender at Appomattox Court House.

That Saturday's bill of fare consisted of nineteenth-century dancing under the columns of Robert E. Lee's mansion, tours of the rooms and prominent graves, fireworks, a candlelight vigil for the dead, plus great talks

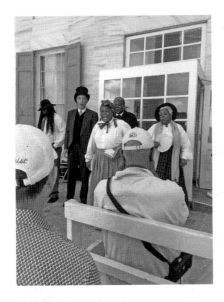

Singers celebrate the reenactment of the enslaved persons' wedding at Custis's Arlington House. *Charlie Clark.*

by park service staff and volunteers. "You may be wondering why there's a good mood here tonight," said park ranger Matt Penrod. "The joy that all the death and destruction was coming to an end" was not shared elsewhere in the South. "But northern Virginia was different, and in Arlington the mood was jubilant."

Mrs. Robert E. Lee, having grown up at Arlington House and given birth to six children there, was still bitterly vowing the war would go on, Penrod noted. Union quartermaster general Montgomery Meigs's anger that General Lee, his former colleague, had defected from the Union led him to place the first officer graves on the rim of Mrs. Lee's garden.

Arlington House—with its commanding view of Washington, D.C.— was known early in the war as a must-hold fort. "Imagine what a couple of Confederate gun batteries could do from here," Penrod said. When Lee signed his commitment to fight for the South there, it cost his family greatly. He would never see the mansion again (though his postwar efforts at reconciliation gave Congress cause in the 1950s to re-designate the site as a Lee memorial).

Though somber, that Saturday's lessons were expertly recounted over the strains of a quartet of fiddlers and guitarists. They serenaded hoopskirted ladies and men in snappy vests or Union military uniforms dancing the Virginia reel in an authentic re-creation of the actual celebrations.

No primer on Arlington House can omit reference to Freedman's Village, the nearby property for blacks released from slavery in the 1860s. Among those liberated was James Parks (1843–1929), who was born at Arlington House, worked as a graves superintendent and helped guide the site's restoration in the 1920s.

Within a year, however, a small makeover was being planned for Arlington's namesake home.

At the Arlington Cemetery auditorium in November 2015, I was privileged to sit in on a National Park Service historians' roundtable discussing how

the well-visited Arlington House might modernize its portrayal of blacks, women and plantation domestic life. Park service regional historian Dean Herrin expressed gratitude to Washington philanthropist David Rubenstein for the previous year's $12.5 million gift to the National Park Foundation. The funds will be used to upgrade exhibits.

Then the highly civil discussion turned to more delicate topics, such as racial bias and nineteenth-century sex between masters and slaves.

Dana Shoaf, editor of *Civil War Times*, presented a slide show of selected covers of his magazine since 1962. He emphasized the dozens of times Lee was showcased but noted that when the occasional African American or women was featured, newsstand sales were not high.

Michael Twitty, an engaging chef and African American history blogger who tours former plantations, offered a fascinating link between the cuisine that originated with clans in West Africa and dishes that survive in Virginia, the Carolinas and Maryland. He criticized the docents at some former plantations who tell tourists more about the opulent furnishings than the harsh realities of slavery. He spoke of the "whistling walk," the pathway between the kitchen and the main house on which enslaved servers had to whistle to demonstrate to the master they were not sampling food.

Perhaps the hardest-hitting talk was delivered by Stephen Hammond, a retired U.S. Geological Survey professional who now does historical research as a seventh-generation member of the Syphax family.

The Syphaxes were among the key slave families at Arlington House. Charles Syphax oversaw the dining room and was the enslaved community's unofficial leader.

Hammond suggested that the stucco slave quarters outside the mansion may not have been typical, given the makeshift huts in lowland woods where the enslaved more likely lodged. He hopes the National Park Service conducts more research on the fifty-seven slaves George Washington Parke Custis inherited from Mount Vernon. Most intriguingly, he proposed a clearer declaration of the rarely dwelled-on relationship between the master Custis and the enslaved Arianna Carter. In 1803, this relationship produced a mixed-race child, Maria Carter, who would go on to marry a Syphax and raise ten children on the plantation. Though handed down through lore, the story Hammond envisions is that Custis, upon inheriting land and human property after Martha Washington's death in 1802, felt "he could do what he wants."

The National Park Service website makes no secret of the relationship, including a statement that Custis in 1826 acknowledged paternity, freed

Maria Carter and gave her fifteen acres. "She's a sister-in-law of Robert E. Lee—there's a direct relationship," Hammond said.

Mary Thompson, research historian at Mount Vernon, told me that information on the former Mount Vernon slaves is limited. But the Custis paternity story "seems pretty well documented"; others thought to be his children were freed, she said.

"The purpose of the outside historians is to give the park and exhibit designers a better understanding of modern scholarship and perspectives on important aspects of history that might have been otherwise overlooked," Park ranger Matt Penrod said afterward. "The ultimate goal is to make the new exhibits more comprehensive in scope, from multiple perspectives, in order to tell the story of Arlington House more thoroughly."

On June 25, 2016, I was pleased to be a face in the crowd for the National Park Service reenactment of the 1821 wedding of two of the plantation's enslaved persons.

The notion that this underpublicized historical anomaly would be commemorated in 2016 would have been inconceivable to Virginians just a few decades ago—let alone the nineteenth-century participants.

The re-created ceremony marrying Maria Carter and Charles Syphax was billed as "Reconstructing the Legacy of the First 'First Family.'" The prelude to the event was a moving performance of Negro spirituals under the Arlington House portico by the Washington Revels Jubilee Voices.

But you needed a special ticket to pack the small parlor for the ceremony—the same room where Lee married Mary Custis in 1831. (Selina Gray, Arlington House's best-known enslaved person, is said to have been permitted to marry Thornton Gray there.)

This Syphax wedding was unusual at the time because the bride, Maria, was likely the unacknowledged daughter of Mount Vernon slave Arianna Carter and George Washington Parke Custis (before his 1804 marriage to Mary Lee Fitzhugh). Maria Syphax, though working as a slave, was emancipated well before the Civil War and was favored in other ways by Custis. (She inherited seventeen acres near what today is the Sheraton Hotel, but heirs had to fight for the property.) "How much Mary and Maria may have known about each other, we do not know," the park service writes, "but they grew up sharing the same spaces and possibly the same father."

George Washington Parke Custis's paternity case was first mentioned in an exhibit fifteen years ago, but "it is now being pushed to the forefront," said Penrod, who is helping with renovations at Arlington House that closed it down temporarily in November 2016. "We try to give all individuals their

own identities. Selina Gray was known for loyalty in preserving Mrs. Lee's belongings, but she was her own agent, too."

Arlington House will "cast a light on history that often gets overlooked because it doesn't meet the criteria of what most Americans recognize," Penrod passionately told the gathered. There will be "no more pushing this history aside." While the house "may be recognized as the Robert E. Lee Memorial, it is much more. It is not a Confederate monument to preserve a special interpretation of history. History is here to tell the truth, whichever it may lead to."

Slave weddings were not recognized in civil law, explained photographer Dean DeRosa, who played the Episcopal officiant. The bride in a period gown was played by Donna Kunkel, a fifth-generation Syphax who came all the way from California, I was told by Syphax family historian Steve Hammond. The spiffy groom was Arlington black heritage stalwart Craig Syphax, a fourth-generation descendant.

Arlington House revamped its exhibits thanks to the donation from billionaire David Rubenstein, and curators coordinated with the National Museum of African American History.

The effort to spotlight Robert E. Lee's handling of slavery on his property is a direct challenge to "the lost cause" myth that emerged in the South in the 1870s to minimize the peculiar institution, an approach the National Park Service calls a "genteel and decontaminated narrative."

DIGGING DEEPER

UNEARTHING DAWSON TERRACE

A county archaeological dig in 2016 uncovered a cache of nearly two thousand eighteenth- and nineteenth-century artifacts at the Dawson Bailey House.

Known to many for its playground, rec center and voting station overlooking Spout Run, the upper Rosslyn structure long known as Dawson Terrace is considered Arlington's oldest stone residence. (It is not its oldest house, as is stated on its out-of-date sign. That status belongs to the Ball-Sellers place in Glencarlyn.)

The Dawson farmhouse played an intriguing—if not a central—role in Arlington history going back to its construction perhaps as a miller's home sometime between 1767 and 1785, according to maps. Civil War drama unfolded there, when both Abe Lincoln and Robert E. Lee were said to have visited the modest farm and orchard. Hence the significance of the dig, which grew out of a repair and stabilization project. Recovered were 243 ceramic objects, 1,603 glass objects, 74 metal objects and 13 other objects.

The hazy story behind the Dawson place (at North Taft and Twenty-First Streets) has intrigued local researchers ranging from the late author Eleanor Lee Templeman to Arlington Historical Society president Karl VanNewkirk, who shared with me tidbits he assembled for an excellent lecture in 2013.

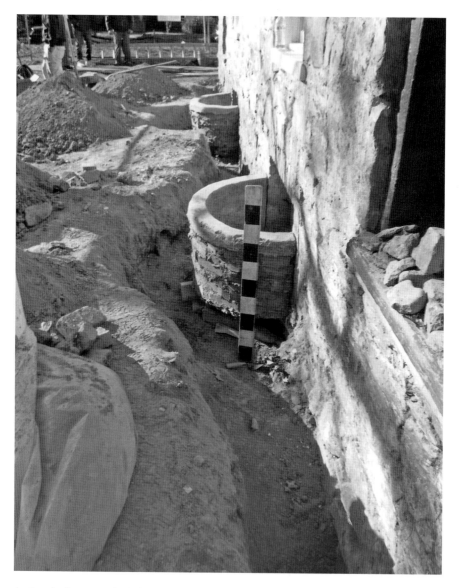

Archaeologists unearthed nineteenth-century household items at Dawson Terrace. *Arlington County Environmental Services Department.*

The most colorful enthusiast was Bruce McCoy, who grew up in Dawson's shadow in North Highlands and knew the last owner, Bessie Bailey, from whose estate the county bought the property in 1955. In the late 1980s, McCoy, as an archaeology student and later a community college teacher,

performed research and led neighborhood walking tours, hoping for a serious dig like the one just completed. (Now retired, he goes by the name Billy Plumb.)

Dawson's high ground (maps suggest a dwelling there as early as 1696) formed part of the eighteenth-century transportation routes of the extended family of George Mason, who owned what is now Roosevelt Island. The name came from a Marylander named Thomas Benonie Dawson, who bought and expanded the house in 1859; his initials are carved in one stone. On the property he called "Rio Vista" lived his two slaves, Patrick and Maria.

According to youngest daughter Bessie Dawson (who later married a Bailey), neighbor Robert E. Lee visited the farm to encourage owners to reject secession. Dawson figured in the federal government's circle of forts defending Washington—ties are documented to the now-vanished Fort Bennett and to Fort C.F. Smith across Spout Run, which were formerly connected by a bridge.

When Union troops crossed the Potomac and occupied the property, they burned the barn, slaughtered livestock and confined the Dawson family to house arrest. Later, romance bloomed between troops and the Dawson daughters.

The Dawson house's continuing high profile as an Arlington landmark is clear from an 1875 painting, *The Ludlow Patton*, by an unknown artist showing it rendered from the Georgetown vantage point.

The 2016 dig was performed by Commonwealth Heritage Group Inc. in consultation with Arlington's Historical Affairs and Landmark Review Board.

The objects—most from the middle to late nineteenth century—include nails and a Minié ball projectile. Others are made of stone, mortar, bone or oyster shell. Also unearthed were manufactured glass tumblers, inkwells, stoneware and pearlware, as well as patterned whiteware and gilded porcelain, I was told by Catherine Matthews of the Arlington Environmental Services Department.

BIRCH FAMILY LEGACIES

During neighborhood walks, I often squint and visualize Arlington back when it was rural farmland, devoid of neon signs and modern suburban curbs.

This little local history game of mine has recently centered on the extended Birch family, eighteenth- and nineteenth-century denizens who owned my East Falls Church neighborhood, among other parcels.

Samuel Birch (1790–1873) was a colonel in the War of 1812 who, records show, earned a veteran's pension of eight dollars per month. He rests with family and slaves at the Birch-Payne cemetery at Sycamore and North Twenty-Eighth Streets. One of his descendants, my high school classmate Amanda Karlson Crabtree, confirmed to me that her grandfather gave the land to Arlington in return for county upkeep of the graves, which were sometimes vandalized.

Arlington contains other Birch clan properties. Another set of Birch graves is hidden by a stand of trees on the Marymount University campus. It contains the graves of one of Arlington's early prominent families; among its members is Caleb Birch (circa 1779–1858), a farmer and constable who built the nearby Birchwood Cabin. Also there is his wife, Mary Bowling; their granddaughter Mariah (1844–1936), who married a William L. Campbell; and their great-grandson Andrew E. Birch (1860–1920). (Avid preservationists among the student body at Marymount in 2015 cleared brush and access to the lot.)

Samuel's brother Caleb built Birch Cabin, a reconstructed version of which still stands off Wakefield Street near Washington Golf and Country Club, and the century-plus-old home named Birchland for another branch of the family. The latter still stands at North Glebe Road at Williamsburg Boulevard.

But a fascinating and often overlooked Birch site sits atop a hill at Powhatan and North Twenty-Sixth Streets. Nearly two hundred years ago, according to Eleanor Lee Templeman's *Arlington Heritage*, Samuel Birch built his cabin there.

Today, the property contains a three-story T-shaped house with white asbestos siding and blue trim that dates to 1890, and probably even further. Called Allencrest for builder William Allen, the home with a view and boxy bay windows is owned by Jeanne Franklin and her husband. Mrs. Franklin in December 2016 kindly showed me the home's handsomely preserved interior.

She has documents on the home's chain of ownership, from Birch to Marcey to Allen to Morsell to Fadeley to Kleeb to Zell and, finally, to the Franklin family.

Thirty years ago, Franklin recalled, the Arlington Historical Society held a daylong event showcasing the home her family bought in 1979. As

War of 1812 veteran Sam Birch built a predecessor home to this one. *Charlie Clark.*

reported in local newspapers, the tour cost five dollars and included cider made from the home press as well as recollections from two older women named Graham who grew up as renters in the house in the 1920s.

They mentioned Sam Birch's cabin (used as a stable until 1930) as well as open fields and pastures and a hired man who hauled crops along a dirt road that led to Lee Highway, which the girls took to school in the district. Franklin still has the society's program. "We've tried not to disturb the essential character of the house, as we love the land, and respect the history and the people who came before," she said.

The Franklins have refurbished original doors found in storage and mimicked old windows when replacing them with modern energy-efficient ones. They have preserved a mantelpiece and tile surround and a cast-iron stove. A single ancient maple tree towers over the home. She has local church reference works mentioning the namesake Allen family members.

Stone vestiges of Sam Birch's water well exist underground on the edge of the current patio, as do stones now in the garden. "It's not lost to history," Franklin said.

Judging by a World War II–era postcard Franklin found in the attic, Allencrest's original address was rural Lee Highway. As I squint from high on the property's hill, I can see that Sam Birch chose his location well.

LIVING IN BIRCHLAND

The historic Birchland home is off Arlington's beaten track. Hidden by stately trees and an imposing stone wall, this Birch property has been ensconced for more than a century on the thoroughfare of North Glebe Road at Williamsburg Boulevard.

The Birch family being one of Arlington's early settling landowners, the elegant plantation-style home—among the county's oldest that is still occupied—sits on property that may have played an intriguing role in Civil War intelligence gathering.

I chatted with longtime owner Jeanne Page. She shared a timeline her late husband Harry produced using early land records and Eleanor Lee Templeman's book *Arlington Heritage*.

Birchland (not to be confused with the Birch cabin on North Twenty-Sixth Street) rests on a site traced back to a 1724 grant from Lord Fairfax to the Robertson family. The Birches inherited it in the latter eighteenth century and by 1812 had built a cabin on the hill, which newlywed occupants Billie and Elizabeth Birch named Birchland Plantation.

That couple in 1828 was bequeathed the surrounding 320 acres. By 1861, the land became part of the Union defense line of Washington, D.C. A tall southern red oak in the yard known as "the spy tree" served as a lookout post, and the cabin was a telegraph station and briefly the headquarters of Major General Winfield Scott Hancock.

The tree, dated precisely to 1606, was cut down as recently as 1995 and is commemorated with a plaque. After three decades, Mrs. Page said, her husband worried that the rotting tree was a threat to the neighbors' house. It is now an eight-foot-round, ivy-covered stump.

The Birch clan in the 1880s sold the property to the Weaver family, founders of W.T. Weaver & Sons Hardware, still in Georgetown. (Walter Weaver was an Arlington supervisor and chief of road building.) The Weavers would own Birchland for eighty years, constructing the current three-story white plantation home with four front columns in 1897.

The Pages purchased it in 1961. "We bought the house to be near schools" (for their two daughters) and close to work for her husband, Bob, an air force

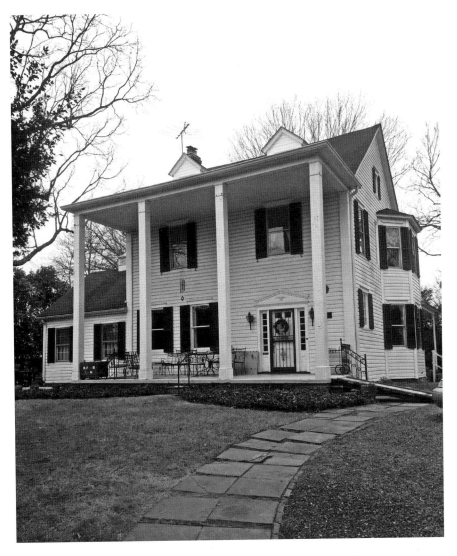

The Birchland home boasts an alleged Confederate spy tree. *Charlie Clark.*

colonel, recalls Jeanne Page, a retired teacher. Her husband put money down on the house before she saw it. "It was pretty run-down, but the price was right," she said. "It was a summer house, so the wind blew nicely through the front porch."

The high-ceiling home with a stone foundation retains its original windows of leaded glass with no mullions and a double-decker bowed triple

window. It has an outside entry basement door and remnants of what looks like an old coal chute. "We found things the Weavers left behind, which my husband kept," Page said. (Indeed, Weaver descendants continue to visit their ancestral home, I was told by Page's daughter Peggy.)

My own memory of the Page place, as a local from the neighborhood, is that it was among several homes that had their front yards sliced off in the early 1960s when the county used eminent domain to widen old Glebe Road. "We were sore" about that, Page said, though they knew of the threat before purchasing the home. The owners couldn't prevent the traffic-easing improvements, but Page's husband—being a "smart cookie"—demanded a quid pro quo for his cooperation.

Colonel Page worked with county engineers, and the result was that the privacy of their historic home today is still protected by that handsome taller-than-expected stone wall.

Slavery and the Febreys

Herewith a discovery in the story of slavery in nineteenth-century Arlington.

John Taylor, a local schoolmate who works at Brown's Hardware, shared with me a remarkable boyhood memory. In the 1960s, at an old house two doors from his in the Overlee Knolls neighborhood, he once ducked into a shed and saw a rusted bolt with chains attached to a wall. Some kind of shackle, he said.

That tall, high-ground white house at 2210 North Madison Street was torn down in 1989. But neighbors had long described it as a onetime Civil War hospital that belonged to one of Arlington's key early landowners, Nicholas Febrey.

In 2015, I set out to learn whether this was patriarch Febrey's first home—mentioned by historian Eleanor Lee Templeman as being on "the north side of Wilson Boulevard, on the hill just west of Four Mile Run." (His later home was where Swanson Middle School stands today.)

The 1860 census shows that Alexandria County (which then included Arlington) was home to 251 slave owners and 982 enslaved people. Of course, most of the slaves were owned by the Custis family at Arlington House. As Arlington historian C.B. Rose Jr. noted, among "the yeoman farmers who made up the bulk of Arlington's population...only the wealthiest could afford slaves."

The one-time home and Civil War hospital owned by Nicholas Febrey. *Anglin family.*

Among those were the Febreys. Descendant Michael Febrey helped me by checking the slave schedules. The 1850 compilation lists Nicholas Febrey as owning seven enslaved persons, while the 1860 update shows him owning five, with sons Henry and John Febrey owning five and two, respectively. I plowed through the Arlington land records, with help from courthouse staffer Moe Mozafar. We traced ownership of the property back from the current owner, Jenkins, to Dell, then to Peete, Lange, Anglin, Neuhauser, Thompson, Shafer, Baumbach, Hicks, Paxton, Brown and, finally, in 1918, to Eliza Febrey, wife of William, the grandson of Nicholas.

Thanks to George Combs and the team at the Alexandria Library's special collections, I found several deeds of sale between Nicholas and his three sons. They included the patriarch's original six-hundred-acre

purchase from George Washington Parke Custis in 1837, from which Nicholas gradually unloaded land to prominent families in Arlington.

One of the deeds held the key. On August 17, 1859, Nicholas transferred to his son John 136 acres. They stretched from modern-day Lee Highway (then called the Georgetown-Fairfax Road) to modern Wilson Boulevard (roughly parallel to the Alexandria, Loudoun and Hampshire Railway). Attached to the deed is a simple drawing of two houses. The companion to Nicholas's house would be his son Henry's home, which shows up on Civil War–era maps and stands today on Powhatan Street (called Maple Shade). (See page 43.)

The idea that Nicholas's house was used as a Union hospital was confirmed in testimony I found from an 1887 court case for southern claims against the federal government. As for the shackles, I asked the final resident of the old house, plumbing supplies merchant John Lange. He recalled no such artifacts, though his sons found bullets.

Ron Anglin, whose family owned the house from 1962 to 1986 and who has long heard Febrey stories, recalls sheds said to have been slave quarters, but no shackles.

I ran the tale by Arlington historian Kathryn Holt Springston, who cautioned, "They may have looked like manacles, but could also be a bear trap."

MYTHICAL MAPLE SHADE

My friends who own one of Arlington's most historic homes opened it up in 2014 to neighbors long curious about what 163-year-old Maple Shade is like on the inside.

Though many doubtless came for the accompanying talk by Arlington County Board candidate Alan Howze, I was pleased to offer the standing room–only crowd at 2230 North Powhatan Street some details and myth busting on the lives of local forebears.

The white colonnaded early classical revival manse was built as a farmhouse in 1851 by Virginia militia captain Henry Febrey. Born to one of Arlington's most important nineteenth-century landowning families—Febreys deeded much of today's Westover and Dominion Hills areas flanking Washington and Wilson Boulevards—Henry and his wife, Margaret Payne, raised eleven children in the home.

Henry Febrey's own Maple Shade. *Steve Etkin.*

Their cotton farm of 177 acres between modern Lexington Street and Quantico relied on slaves. (A story survives of a homebuilder a few decades ago discovering ancient shackles in a backyard on Madison Street and failing to preserve them.) Aside from serving as a captain in the 175th Regiment of the 2nd Division of the Virginia Militia, Henry Febrey served what in his time was Alexandria County as a justice of the peace. He attended Dulin United Methodist Church, still open on East Broad Street in Falls Church.

During the Civil War, most of the Febreys sided with the Union (the known exemption being Henry's brother Moses).

The richest source for the story of Maple Shade is the 1959 book *Arlington Heritage* by Eleanor Lee Templeman. I have long proclaimed myself a Templeman fan. (I was probably the last to interview her, having phoned her on a reporting assignment in 1990 and heard her say, "I'm sick in bed but I'll talk to you." A week later, I read her obituary.) But her write-up on Maple Shade may have gone astray.

Because of action during the Battle of Munson's Hill (a minor clash fought in the autumn of 1861 on the edges of Arlington and Bailey's Crossroads),

Henry Febrey's home "bears within its walls hidden scars," Templeman wrote. "One shot came through the dining room and sheared off the leg of a table set for dinner, without disturbing the meal thereon."

The current owners of the elegant (and very livable) home, Steve and Nancy Etkin, despite executing countless historically respectful renovations inside and out, have never found "scars." My efforts with Arlington Public Library archivists to nail down the claim came up dry.

But give Templeman credit for describing how the home evolved after it passed from the Febreys in 1919. A buyer named Albert Paxton began improvements that included reversing the front and back entrances and adding columns, dormer windows and a rooftop balustrade. The name Maple Shade came about from the "stately grove of trees framing it."

As the neighborhood suburbanized in the 1950s, a subdivision sprang up around the site. The home's ownership turned over, from Paxton to Coxen, then to Hoge, Logtens and, finally, in 1984, Etkins. Even when adding a carport, Steve and Nancy preserved the design's integrity. Steve showed me what seems to be an early 1950s snapshot showing horses in the front corral.

Not all passersby realize it, but remnants of two stone columns that once marked entry to the farm stand today at Quantico and North Twenty-Second Road.

Maple Shade is among the few Arlington homes with real (closable) shutters. It's worth a peek—even if you don't get inside.

THE OLD MARY CARLIN HOUSE

On a hill overlooking the woods of Carlin Springs Road stands a nineteenth-century flat-log home that is one of Arlington's earliest.

The Mary Carlin House (built circa 1800) is also among our county's coziest homes—a compromise between the duties of historic preservation and the rights of private owners to livable space.

The property's historical plaque and the write-up in Templeman's *Arlington Heritage* invoke a roster of early Arlington families. Original builder William Carlin, who had a reputation as George Washington's tailor, deeded it to his granddaughter, Mary Alexander Carlin, who had been born there. As an unmarried teacher, she lived there until 1905 and became the last to be buried in the Carlin family cemetery up the road.

The pipe-smoking Mary Carlin was born in this circa 1800 house. *Samantha Hunter.*

Judging by her photo, which shows her in an unladylike pose and with a corncob pipe, Miss Carlin seemed to current owners Charlie and Judy Titus "a bit rough." This would also describe their experience of buying the place in 1967, when it had stood empty for three years after having passed through decades of ownership by the Lanes and the Broyles.

"It was a black hole of Calcutta," said Judy Titus, a homemaker who displays her collection of more than three hundred dolls in a decor invoking a quaint bed-and-breakfast. "It was a mudhole," part of three and a half acres invested in by a friend for whom Charlie Titus worked as a drywall contractor.

Rather than the Tituses grabbing up the historical attraction, it was more a matter of the construction entrepreneur begging them to "take this house off my hands," Charlie recalls. He was reluctant, but Judy decided to visit and "climb over the trash heap" of a vintage home that they recall passing as children on the school bus on (at the time) two-lane Carlin Springs Road.

The Tituses plunked down $13,000 and assumed challenges that included rescuing the pre–Civil War locust wood ceiling beams, which needed new mortar in a structure that once housed five fireplaces.

They endured noise from bulldozers working on new Dittmar homes next door as they cooked on a Coleman stove by candlelight before power lines

were connected. "We've been working ever since," she jokes as she conducts a tour of the creature comforts—an added family room and master bedroom, modern kitchen, screened patio, barbecue, hammock and gazebo. These features expanded on the 1923-era, barn-shaped additions and gable.

On the Titus living room wall is a framed collection of rusted spikes, hinges and latches they unearthed. They turned the old covered well in the front yard (now dry) into a shed.

In the early 1980s, pressure came from the county for the Tituses to sign a twelve-page covenant that would require them to obtain future permission to add shutters or paint and to notify authorities if they planned to move. "It was nuts, and no one signed it," Charlie said.

The Arlington Historical Society came with a pitch to be included on tours—to which they agreed, in 1969, 1974 and 1993. (Judy saved the resulting news clippings.) "But some thought we should furnish with a dirt floor and stick furniture," she complains, which would be a far cry from the handsome retirees' retreat they maintain today.

Today, passersby do knock on the door of the Mary Carlin House. "One even asked if she could rent the place for a wedding," Judy said. "But that's something I wouldn't even allow my own daughter."

MOVING THE EASTLAWN HOME

When a historic home is threatened by a developer, preservationists should mull the option of jacking up the house on a flatbed truck and moving it to more welcoming pastures. Of course, it would not be cheap.

A famous application of such a remedy in Arlington involves the nineteenth-century Eastlawn home at 301 South Kensington Street in the Glencarlyn neighborhood, stomping grounds of the county's seminal Ball family.

That venerable wood-frame, two-story home was transported not once but twice—the last having been photographed forty years ago this month. A collage showing the transport is displayed at the Glencarlyn Branch Library with shots taken by Bill Barns, thanks to efforts by Eastlawn enthusiast Dudley Chapman.

Eastlawn was originally built in 1868 as a summer house to the larger home of Confederate Civil War veteran Henry Howard Young, according to the *Glencarlyn Remembered* history. Descendants expanded the bedrooms

and parlor into the 1930s, when it was owned by the Stetson family, whose daughter Margaret was born in 1900. It was she who would make the preservation moves.

When law professor Charles Stetson (her father-in-law) died in 1958, the land was sold to builders of Northern Virginia Doctors Hospital. Eastlawn was cut in half and moved (at a cost of $8,000) closer to Carlin Springs Road. Upon reassembling it, the Stetsons added a Mount Vernon–style center hall.

But by 1966 the county was ready to condemn the property to expand the hospital, so authorities bought back the land to build the medical offices that stand today at 611 Carlin Springs. It was déjà vu all over again.

Margaret Stetson, a retired English teacher, had moved to North Arlington. She was seventy-five years old in 1976 when she got a call from hospital administrator Ray Hemness saying she could have the house in which she was raised for peanuts if she would move it.

Lo and behold, Stetson wrote in a personal history, Marion Sellers, owner of Arlington's oldest residence (the Ball-Sellers House), offered to sell Stetson two lots.

But obstacles materialized. Neighbors objected, as did the Long Branch Nature Center, which feared damage to wildlife. And the first cost estimates were astronomical, including $104,000 for the Virginia Electric and Power Company to drop telephone wires so the home's tall chimney could pass. She had to petition the county to help pay.

Stetson got help from her home improvement jack-of-all-trades, Bob Shannon. She found a Fairfax contractor who planned a two-block route at a cost to her of $56,000 (VEPCO came down to $23,000).

On June 16, beginning at 9:29 a.m., the *Washington Post* reported, the home traveled on a flatbed truck supported by steel beams on dollies equipped with aircraft tires, preceded by a bulldozer. It moved through the hospital parking lot and woods, and the trip ended at 5:00 p.m. "Seventy-five or eighty people watched," recalled Shannon. "A carpenter took out the ductwork and numbered the pieces so it could be put back together."

After years of helping Margaret Stetson refurbish the home, Shannon bought it. He and wife lived there from 1983 until April 2016 (when his daughter took over), opening it up occasionally for tours on annual Glencarlyn Day.

"I am trying to save a beautiful old house," Stetson wrote in 1976 while negotiating the big move. "Does Arlington have so many it can afford to destroy what can never be replaced?"

ARLINGTON AND *DAMN YANKEES*

There's only one mom in the universe who could tell me, "Here's my daughter's bedroom, where 'Damn Yankees' was written."

That reference to the book that became the 1950s hit musical was uttered in Arlington by Moley Evans, who lives with her husband, Nicholas, and two children in the historic house known as Alcova (an abbreviated form of "Alexandria County, Virginia"). This fine property on South Eighth Street in Alcova Heights dates as far back as 1836. The site was a Union hospital during the Civil War.

Evans, a teacher now running a day camp, took me on a tour to show how she and her husband, a federal relations professional, have modernized an Arlington institution while preserving its other-era charm and literary flavor.

Originally a farmhouse under the names Spring Hill Farm and Columbia Place, Alcova was built by Washington carriage maker John Young, according to Eleanor Lee Templeman. It is among the county's oldest structures, after the Ball-Sellers House (1760) and Arlington House (1802).

In 1915, the Young family sold the home and 142 acres of orchard to state senator Joseph Cloyd Byars of Bristol, Virginia. In the 1920s, he added four handsome columns and a porch, along with gardens and brick walkways, scavenging a mantel and shutters from abandoned homes in Georgetown and wrought-iron gates from the U.S. Capitol. Byars built the surrounding subdivision.

The next owner, Allen Coe, sold the home in 1950 to a pair of writers on their second marriages. Radio playwright Lucille Fletcher (1912–2000) wrote the thriller *Sorry, Wrong Number*, made into a 1948 movie starring Barbara Stanwyck and Burt Lancaster. Her husband, Douglass Wallop (1920–1985), wrote the 1954 novel *The Year the Yankees Lost the Pennant*, which became *Damn Yankees*.

In 1964, Alcova went to Smithsonian botanist Dan Nicolson and his zoologist wife, Alice, who ushered the home into the modern era, complete with Arlington Historical Society tours.

The Evanses, living in nearby Arlington Heights, learned by word of mouth in February 2012 that the Nicolsons were putting Alcova on the market after having lived there fifty-six years and raising their children in the house. For the price of $950,000 for a house Moley fell in love with, the couple gained nearly an acre of land with tall oak and award-winning gum trees, a modern kitchen, a stylish wooden curved staircase and French doors, capped off by a wrought-iron "ALCOVA" sign on the screen porch.

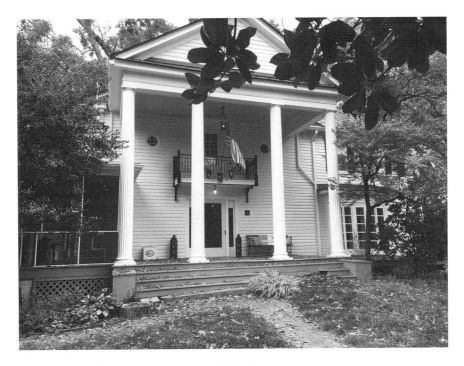

Alcova, where a literary gem was penned. *Moley Evans*.

In return, they had to do heavy repainting (preserving some vintage wallpaper in a closet), lift a bedroom ceiling, customize the kitchen and close off a basement stairway designed for the "help."

Where many old houses are "creepy, this one was warm and friendly," said Evans, enjoying the pleasant bells ringing from the nearby United Methodist church. She's pleased when passersby stop in.

BUYING THE CHIEF JUSTICE'S HOME

Arlington has long hosted its share of residents who are power players across the Potomac. But familiarity didn't lessen the thrill on May 21, 1969, when news broke that President Richard Nixon was naming D.C. appeals judge Warren Burger as chief justice of the U.S. Supreme Court.

Residents near Burger's home on North Rochester Street off Williamsburg Boulevard were happy to share memories of the local hoopla, from a time

when a high court justice could be nominated, confirmed and sworn in within five weeks.

A sixty-one-year-old Minnesotan, Burger lived with his wife, Elvera, in a tree-shielded "modest, two-story 110-year-old white shingle farm house" on six acres called Holly Hill, as described by the *Washington Star's* "Woman's World" section.

As news trucks descended on the street (said to contain Arlington's last septic tank), Mrs. Burger remained in seclusion behind a "No Trespassing" sign while a law clerk answered the door.

When Nixon presented Burger to the press at the White House, the judge pleased cameramen by giving his wife a kiss. Elvera Burger said she was determined not to change with her husband's elevation. After the June swearing-in, the couple and their two grown children joined other relatives for a "celebratory dinner" at their home.

Neighbor Kim McHugh Arthurs, then fifteen, remembers the set-off house as scary, and that the Burgers on Halloween gave dimes rather than candy. Burger used to disguise himself so he could walk his dog, she said. "The neighborhood thought that having the chief justice meant we might get our street plowed faster."

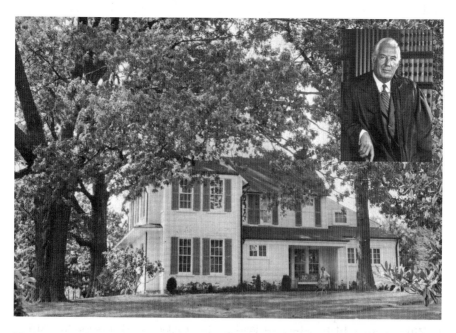

The now-demolished house of a chief justice. *Burger family via Eleanor Lee Templeman.*

Reva Backus, who moved to the neighborhood in 1952, said it wasn't unusual to see Burger riding his horse. He resembled the pied piper, with kids following him. Those stabled horses were often cared for on Saturdays by Joanna Carlson, who told me that Burger paid her by allowing her to ride the animals Story and Vicky, who are buried on the property. On the big day, "I remember getting ready for school and a knock on the door," Carlson said. "It was a tall reporter named Sam Donaldson needing the phone." She noticed as Burger switched from commuting in a white Volkswagen bug to a limo.

Perhaps the most vivid memory comes from Chris Reynolds, owner of City & Suburban Homes Company and a partner in Reynolds Brothers Inc. He bought the property from Burger in 1984 and built the twenty-four Brandymore homes. "We found out he was considering selling and thought we could do something creative," he said. "We reached a draft deal on the porch of the house. He had a significant law team looking over his shoulder, and when the numbers were close, he got up and we shook hands."

Because Arlington is a "small town," Reynolds said, other developers got wind of the sale and swooped in with higher offers. "I became nervous, but decided that Burger was probably the most honorable man in the country," he said. He called the jurist and asked to come over. "We shook hands and had a deal, Mr. Chief Justice, didn't we?" Burger's reply: "Of course, Chris, we have a deal."

After Burger moved to the Analostan development off Old Dominion Drive (near colleague William Rehnquist), Reynolds kept in touch, visiting Burger in his chambers. On the wall of the homebuilder's office is the contract bearing the chief justice's signature.

Billy Martin's Mansion

Of all the mansions atop select hills in Arlington, one has stood out in my mind since my boyhood.

Whispering Oaks, so named on its plaque at the corner of North Glebe and Chesterbrook Roads, affords a swell view of Walker Chapel. The stately pale-red-brick home fronted with eight columns is surrounded by a wrought-iron fence and two curved storybook driveways bracketing a sloping lawn. Inside are 5,891 square feet, six bedrooms and eight bathrooms, according to Zillow.com, which estimated Whispering Oaks's market value in 2015 at $3.5 million.

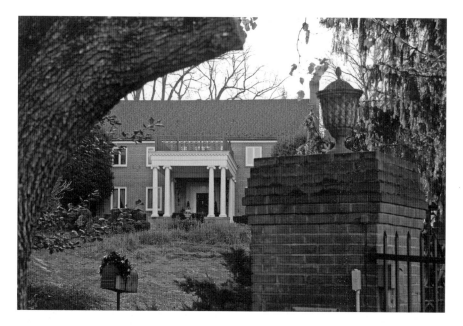

The former mansion of restauranteur Billy Martin. *Samantha Hunter.*

The owner, Hakan Yavalar, is president of a management firm in Arlington and a 1977 graduate of Washington-Lee High school. He bought the place in 2002 for $2.3 million, county records show. He's very private and did not respond to inquiries.

So I went straight to the family who built Whispering Oaks. Billy Martin, current owner of Martin's Tavern in Georgetown, is one of six offspring of the Martin family who spent childhood years in the house. His colorful memories include the fact that the mansion was designed by his late mother and father, also called Billy Martin (like his grandfather and great-grandfather), a Golden Gloves boxer and pro-am golfer down the street at Washington Golf and Country Club.

Those four generations of Irishmen became known for Martin's Tavern (opened in 1933) and nearby Billy Martin's Carriage House (1953–79) and as pillars of Georgetown. The tavern, at which I recently enjoyed a steak, has, over the decades, hosted Harry Truman, Lyndon Johnson and Richard Nixon and preserves the booth where John F. Kennedy proposed to Jackie.

Billy IV, age fifty-five, explained how he lived in Whispering Oaks until age nine, when his parents divorced and moved him to Florida. "It's a magnificent home and I loved it," he said. His grandfather, in the late

1920s when Chesterbrook Road was farmland, built a two-story, wood-frame house with a wraparound porch on the same property. Billy's father inherited it in 1949 and substituted Whispering Oaks in 1954.

"When I was a kid, Chesterbrook and Glebe were only two-lane roads, and there was more property to be had," he said. The original eight acres were cut to six in the early 1960s, when Glebe Road was widened. Martin recalls his father's friendship with the neighboring Weaver family, who for decades owned a Georgetown hardware store. "Dad was the longest living member of the country club and made a lot of money playing golf." He stored some of his gambling winnings in walls of the wood house, Martin said.

In the mid-1980s, Martin's father sold a slice of the property to J.L. Albrittain Company, which built the gated community Carriage Hill. "He had to get approval from the county and sign a deal that basically said he would never subdivide again," the son recalled.

Before he died in 2004, the father tried to sell Whispering Oaks several times. An "Arab sheik" once drove by in a fleet of limousines and brandished a suitcase with $1 million, Martin recalls. "Dad closed it back up and said come back with another just like it." The sheik never returned.

"Dad turned down $4.5 million after the dot-commers" got rich before he decided to move to Florida, Martin said. "I always thought it would pass to me, but Dad said I couldn't afford all the taxes."

CHIEF POWHATAN WAS HERE

Our county's best-hidden landmark could use some TLC.

The original Powhatan Springs, off Wilson Boulevard behind the Dominion Hills swimming pool, was once a vital watering hole for Indians, soldiers and presidents.

But when I poked around the site on Labor Day 2016, Arlington's unusual freshwater spring appeared worse for wear. The stream still ripples gently, but its concrete footbridge is tilted and in disuse. The lonely wooded setting near a picnic table and volleyball net is easy to ignore.

Yet folks great and ordinary have been wetting their whistles here going back to the seventeenth century—and beyond, if you consider nearby Indian trails. Chief Powhatan himself, the legend goes, held harvest festivals here.

According to the 2004 Dominion Hills Neighborhood Conservation Plan, "Captain John Smith's map of 1612 fixes the northern boundary

After centuries of use, Powhatan Springs could use refurbishing. *Samantha Hunter.*

of the Confederacy of Powhatan in the vicinity of Powhatan Springs. Archaeologists and others have uncovered artifacts—including fragments of vessels and quartz implements for stone carving—nearby, indicating the former presence of an Indian soapstone workshop at the springs."

The obligatory link to George Washington came during the French and Indian War, when British soldiers returning from General Edward Braddock's defeat in 1755 "refreshed themselves and disbanded near these same springs."

In the period around the Civil War, Confederate sympathizer Moses Febrey (the son of major Arlington landowner Nicholas Febrey) built a house nearby and leased the springs to the Harper Company. That operation bottled the waters and made daily deliveries in the District of Columbia, including to the White House. Powhatan Springs was also used for cold storage, and it is said that Teddy Roosevelt drank from it during horseback rides through Arlington.

By 1920, the area we call Dominion Hills was known as the Powhatan Springs neighborhood, which included a roadhouse that is now the pool's quaint clubhouse. In the mid-1950s, when the Dominion Hills Recreation Area Association was formed, founders named the pool Powhatan Springs (a carved sign remains over the locker room entrance). That name also appears above Dominion Hills on the club's sign facing the street. The name "Powhatan Springs" was later attached to the nearby skateboard park.

Arlington historian Eleanor Lee Templeman featured Powhatan Springs in her inaugural column in the *Northern Virginia Daily Sun* of March 22, 1957, applauding the recent formation of the Arlington Historical Society and sounding the alarm about vanishing landmarks.

Current society board member and mortgage banker Johnathan Thomas, who grew up in the neighborhood, recalls exploring with his pint-sized pals the drainage pipes leading to the grilled entrance to the Powhatan Springs tunnel.

My old football coach at Yorktown High School, Jesse Meeks, who was resident manager of the Dominion Hills pool beginning in 1955, sent me his recollections. He used to receive visits from neighboring farmer Nelson Reeves. In the 1970s, an Asian church group that rented the clubhouse cooked with watercress taken from the springs.

By 1974, the springs' entrance and stone storage house were in disrepair. So the Powhatan Springs Woman's Club (now defunct) won a county grant and worked with the Dominion Hills association to restore the masonry. A November 1975 dedication, the *Arlington News* reported, drew three state

delegates to hear remarks from woman's club president Mrs. Skip Jeffries and association leader Donald Van Shiver.

A half-century later, I say it is time for a new restoration—and a nice, enduring Powhatan Springs historical marker.

REMEMBERING EAST ARLINGTON

Are you familiar with East Arlington? Neither were most of the nearly one hundred persons who turned out at Central Library on April 3, 2014, to hear a local historian describe this bygone African American neighborhood torn asunder in 1942 during construction of the Pentagon.

East Arlington (or, as its original 1892 subdivision was called, Queen City) comprised 903 souls living in 218 households near where Columbia Pike today gives way to the Air Force Memorial.

We know details thanks to the labors of Nancy Perry, a successful doctoral candidate at George Mason University whose research into Arlington's black heritage has twice brought her to the podium of the Arlington Historical Society. She unearthed the 1940 census report for that slice of our county; pored over land records; scoured oral histories, rare photos and news articles; and interviewed ten living former East Arlingtonians. (Several came to her talk.)

Perry revived the heartbreaking drama of how, in the fervor of preparing for World War II, the War Department used eminent domain to clear a twenty-seven-acre neighborhood of largely powerless minorities. They were forced to scramble for new housing and livelihoods. Armed with photos of the wood-frame houses (on unpaved streets) and family names and occupations, Perry humanizes this lost community.

East Arlington was needed not for the Pentagon itself, but for access roads and parking demanded by the workforce commuting to Arlington from D.C. The constitutional tool of eminent domain can encompass many versions of just compensation—reimbursement not just for land and homes but for moving costs and foregone business, Perry notes. The government took the cheapest route, which meant paying market value—set by the government.

Residents—both owners and boarders, many of them children—were given three weeks' notice, Perry recounts. Many black citizens had nowhere to turn and no place to transfer their possessions. Some lost their earning power when the government also shut down nearby brick and coal plants, where many East Arlingtonians worked or serviced with daily lunches.

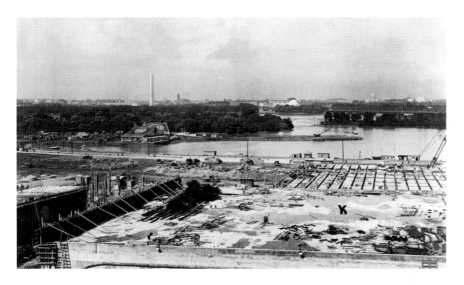

Building the Pentagon meant displacing communities. *Library of Congress.*

Two black churches—both of which had only recently been renovated—were demolished. "But not even the War Department," Perry said, could stop the congregations and other evictees from reforming in black enclaves Nauck and Johnson City. Newspaper coverage, Perry noted, was impersonal, all from "management's perspective." The exception was an account of a protest letter to First Lady Eleanor Roosevelt, who pressured the House Military Affairs Committee to provide the newly homeless temporary alternative housing.

The sixteen-month rush to build the Pentagon was a 24/7 barrage of pile-driver noise. The residents of East Arlington could only watch from their condemned front stoops.

I asked Perry, who teaches geography at Northern Virginia Community College, how she got immersed in Arlington's black history. "I did a mapping project for a class at George Mason," she said. "The assignment was to display census data, and I decided to display the black population on a map of Arlington. I discovered that in 1950, almost all Arlington's blacks lived in only three census tracts. I grew up in Montana, totally white, so I'm embarrassed to admit I had no idea why all the blacks lived in just three tracts."

The Bygone Carver Apartments

The teardown trends in Arlington housing in 2016 got the best of the historic George Washington Carver Cooperative Apartments.

In February, the wrecking ball hit the units off Columbia Pike near Washington Boulevard that for seventy years had been a mainstay of the working-class African American community—with links to the nineteenth century. Credit both the county government and the builder of the now-on-the-market luxury townhomes for honoring their historical legacy.

Built in 1945 and designed by the dean of the Howard University School of Architecture, Albert Cassell, the Carver apartments were "the most recent incarnation of the housing provided by the federal government for Arlington County's African Americans since the founding of the Freedman's Village in 1863," said a county staff report. "With the government's dissolution of the village in the late 1890s, its occupants dispersed throughout the county, settling in nearby neighborhoods such as East Arlington, Queen City, and Johnson's Hill."

The historic Carver apartments meet the wrecking ball. *Tom Dickinson.*

But when the wartime feds decided to build the Pentagon, Navy Annex and accompanying access roads, those communities were dispersed again. So the federal government built the forty-four garden apartments in eight multiple dwellings on 3.3 acres at South Rolfe and Thirteenth Streets, near Hoffman-Boston School.

The apartment complex's namesake, George Washington Carver (1861–1943), was born in slavery in Missouri and became a botanist, inventor and educator as well as an agricultural innovator. Other housing units bearing his name are in Naples, Florida.

In the Arlington version, according to the staff history, the federal government in 1949 offered to sell the units to the county, which declined, then to the tenants, who formed a cooperative. They landed a $123,000 Federal Housing Administration loan from the James W. Rouse Company. The cooperative paid it off by 1974.

"What I remember most is that it was always well maintained and families were close-knit," I was told by Craig Syphax, curator of the virtual Black Heritage Museum of Arlington. "Those who lived there comprised, for the most part, a solid blue-collar, military and some professional families. Co-op leaders met regularly to address general maintenance and upkeep issues. The play area provided fun times for pre-teens on the sliding board and monkey bars."

The county and the Historical Affairs and Landmark Review Board applied for National Register of Historic Places designation. But in 2015, the developer won out by rights, though the owners were divided over the desire to sell, I was told by Arlington preservation planner Rebeccah Ballo.

In October 2015, the county board approved naming the nearby mini-park George Washington Carver Park, as recommended by the Park and Recreation Commission and the Arlington View neighborhood. The Arlington Public Library and historic preservation staff interviewed residents and the developer to build an oral history. Tom Dickinson of the Arlington Historical Society took photos of the demolition.

"It's a loss of historical architecture," Ballo said. "But we won wonderful mitigation for the county and the country," she added, citing the oral histories and two "beautiful markers," one related to the homes and one about the architect.

The luxury townhomes sprang up in just months. What are now called the Carver Place townhomes, designed by Craftmark and honoring the history, were priced from $689,000 to $875,000, I was told by McWilliams/Ballard realty vice president James Lobocchiaro. The markers went up in time for the new year.

BOWLING IN ROSSLYN

The glass-tower village of Rosslyn is known historically for its long-vanished pawnshops and brothels. But in the first half of the twentieth century, it was the place for a more wholesome activity: bowling.

This was among the heritage tidbits I learned when I sat in on the weekly gathering of three eighty-something siblings of the Davis family. We reminisced about shared memories of growing up in Cherrydale, including nifty details about how Arlington has changed through the generations.

Lee, Joan and John Davis are as Arlington as Lee Highway. All were born in the 1930s to a father named Ernest Galt Davis, the bowling alley owner, racehorse trainer and nationally recognized marbles champion by age twelve. While swimming in the Potomac as a teen, he had taken a shine to Helen (née Davison), a Cherrydale neighbor who was a tomboy athlete in the first graduating class of Washington-Lee High School.

They wed in 1931 and raised their kids at 1729 Nelson Street (originally Fairfield Street). "This probably was Cherrydale's best time," said daughter

Rosslyn bowlers raised wartime funds. *Hitt family.*

Joan, who went on to marry neighbor Russell Amos Hitt, scion of the construction firm family. "When it rained, everyone came to our front porch and played," recalled eldest daughter Lee, a former Pentagon employee.

The Davis kids went to Cherrydale Elementary (twenty years before I did) and attended St. George's Episcopal Church (as did I).

Their father's Rosslyn Bowling Alley (duckpin) was at 18 Harlowe Avenue (now Moore Street). By the 1950s, nearby competition included the Rosslyn Ten Pin on Moore Street, Clarendon Bowling Center on Irving Street and Colonial Village Bowling Center on Wilson Boulevard. (In the 1960s, my contemporaries bowled tenpin at Skor Mor on Quincy Street and duckpin at Pla Mor on Fairfax Drive at Glebe Road.)

News clips show the Davis parents starring in a 1930 national duckpin tournament in Washington. They set records in mixed competition. "Rosslyn Girls Real Threat in Pin Test," read a headline about the "Bowling Belles."

Galt Davis hired a boy named Billy Stalcup (his family ran McLean-based furniture and hardware stores), a friend who became a nationally recognized duckpin champ. In 1943, the alley raised $96,000 for the war effort.

Daughter Joan recalls accompanying her father into a black neighborhood to pick up the young boys who performed the monotonous job of pin setting. Her father told her, "Don't even think for one minute that you're better than those boys—you're just luckier."

One of the black employees drowned in the Potomac. Other such tragedies were recorded in the privately published history of the Davis family, which extended back to the late nineteenth century. Their grandfather was a Potomac tugboat captain based in Alexandria before he died at their Cherrydale home.

Son John Davis, who worked for the bowling alley and Cherrydale Sports Fair, wowed me with his recollections of nearby businesses: Bernie's Pony Ring in Lyon Village, Sam Torrey's Shoe Repair (still around) when it was at Monroe and Lee Highway, the Luzi family (who owned a cleaners, a car wash and a candy store) and Temple's Barber Shop in Cherrydale. In Rosslyn, he remembers Samaha's market, Dickey's Seed Corn, Arlington Trust and the Jewel Gallery. We knew the same Cherrydale families—Newman, Dortzbach and Griffin—and their gardens and crops.

It was a time and a place, said Lee, "When everyone took care of everyone. And no one locked their doors."

C&O CANAL MEMORIES

It took me sixty years, but I finally visited quaint old Cumberland, Maryland. That's the nineteenth-century terminus of the 185-mile Chesapeake & Ohio Canal, which played an evocative role in my Arlington boyhood.

Growing up within walking distance from Chain Bridge, my pals and I had our earliest fishing experiences on the Potomac and the parallel canal. My father took me on walks along its towpath, where we saw the long-since-decommissioned mule-drawn *Canal Clipper* boat. The sight may have planted my first notions of long-distance commerce and changing technology.

These memories survive from a time when the canal was in disrepair. (Its restoration as a park, championed since the mid-1950s by Supreme Court associate justice William O. Douglas, didn't get going until 1971.)

The original canal, begun in 1828 in Georgetown to provide shipping access to points west, does have Arlington ties, I was assured by Arlingtonian Mike Nardolilli, then-president of the nonprofit C&O Canal Trust.

Arlington, of course, was part of Alexandria County when the canal was conceived (it separated in 1920).

The Old Town Alexandrians in the 1830s built their own seven-mile canal hugging the river; it ran past Four Mile Run through Arlington and connected to Georgetown. A key part of it was the one-thousand-foot Alexandria Aqueduct near what became Rosslyn and Key Bridge. Alexandrians' need for Virginia canal water may have been why many supported retrocession from the District of Columbia in 1846, according to C.B Rose Jr.'s book *Arlington County, Virginia: A History*.

Nardolilli said he "always felt that some of the water-filled depressions on the Virginia side along the George Washington Memorial Parkway are vestiges of the Alexandria Canal."

Shipping on the C&O Canal faded decades before it closed in 1924, superseded by railroads and steamships. But its watery pathways set the stage for my childhood experiments in recreational fishing.

Springtime in the early 1960s brought grownup cries of "The herring are running!" So my buddies and I in our *Gunsmoke* and *Bonanza* T-shirts would traipse through the woods carrying our bamboo poles and red plastic bobbers.

Afraid to clamber down the rocks to fish in the rapids of the Potomac, we often crossed Chain Bridge and descended the steps to the canal. But not without stopping to chat with the "Captain," who ran the bait, tackle and Pepsi shack alongside an Amoco (earlier a Shell) gas station at the bridge's

Fletcher's boat rental on the canal. *Bonnachoven.*

Arlington entrance. (The small business dated to the 1930s and was owned by a Meredith Capper, according to Carole Herrick's fine book on Chain Bridge, *Ambitious Failure*.)

The "Captain" once persuaded us ten-year-olds that, instead of using live bait, we should buy his reusable rubber worms. I can still hear my friends' mocking jabs on the way home after a day when we spent hours catching no fish: "Hah! Fake worms in the canal!"

CROSSING THE POTOMAC FROM FLETCHER'S BOATHOUSE

Most Arlingtonians are familiar with Fletcher's Boathouse, the canoe- and kayak-rental facility operated out of the nineteenth-century stone structure on the D.C. side of the Potomac along the canal. In 2015, I was approached by Joseph Fletcher, who, before the National Park Service concessionaire took it over in 2005, worked there as an expert fisherman and fourth-generation stalwart of that family. He offered fond memories of cross-Potomac family ties to Arlington.

Fletcher, now in his eighties and living in McLean, told me his grandfather married into Arlington's famous Donaldson family, whose property off North Marcey Road gave its name to the swimming club. "Both he and his wife are buried at Walker Chapel along with my great-grandfather and his wife," he said.

The Donaldsons' property (modern-day Potomac Overlook Park) was also the site of the "Little Italy" rock quarry in the early twentieth century. Joseph Fletcher recalls rowing there with some older boys in the 1940s two or three times a week. "I also remember riding with my dad to see an older lady, his aunt whom I think must have been my grandmother's sister with the maiden name Donaldson, at the end of Marcey Road."

Fletcher said she had two large boxwood bushes and covered her living room chairs with newspapers as a shield from the sun. "I also remember a small house midway up the hill just below Donaldson Run that was vacant, and which burned down one night," he said. He also remembers the boilers left over from the Potomac cliffside quarrying that remain today. (The quarry contributed stones that built much of Georgetown University.) "We used to fish for white perch out from the boiler and two boxes just upstream from

The old bait and beer store at Chain Bridge. *Carole Herrick.*

what was called the Guinea Camp back then," he said. "We also fished off the Virginia shore at a place called Dixie Landing."

The old boatman who spent sixty years on the river still owns a partially rotted fishing net rim that his friend Lee Havener's father used skillfully. And he recalled a cement-block manufacturer named Gum Boots who lived in a cement blockhouse off Old Glebe Road near Walker Chapel. Boots's bricks helped construct much of Cherrydale.

Most intriguingly, Fletcher said he recalled a "beer joint," Mackie's, where Pimmit Run reaches Chain Bridge. It was across the Virginia-side bridge entranceway from the old fishing tackle shop and gas station many of us recall being there until the early 1960s.

"The Virginia blue bells are so pretty each spring there," Fletcher said. "I go to shore to walk amongst them and remember people who have passed away that were friends of the boathouse."

Noble Institutions

The Woman's Club's Place of Her Own

I had the chance to share local history tales in 2015 with the Woman's Club of Arlington. Its members responded by sharing with me their own rich slices of history.

At their headquarters on South Buchanan Street (the property itself is a neat strand of their story), I perused, thanks to members Ann Swain and Sandy Newton, the club's archives dating to the 1930s. The artifacts compose a portrait of our county from an era in which, though gender roles differed, Arlington's civic-mindedness was stronger than ever.

The General Federation of Women's Clubs (one hundred thousand strong) has roots going back to 1868. That's when New York journalist Jane Cunningham Croly was denied entry to a lecture by visiting author Charles Dickens. In response, she formed her own club. The members threw themselves into charitable work, library activities and advocacy for food safety.

By 1890, women's clubs numbered sixty-three, and a decade later they chartered the federation's headquarters in the nation's capital, where, since 1922, it has stood at 1734 North Street NW.

The Arlington branch was born on October 22, 1931. Surviving minutes from June 4, 1934, record "an attendance of 45 and a number of guests." Members said the Lord's Prayer, sang songs and, once, presented a silver

platter to a retiring president. They planned bake sales, bazaars and theatrical productions for scholarships and the Red Cross.

Nearly all of the women went by their husband's name. Scrapbooking, then in vogue, meant that the Arlington club's books were lovingly assembled with wholesome Dick and Jane–type drawings and were "dedicated to conservation of paper and time."

Club archivists saved everything, including news clippings from the *Washington Star*, *Washington Post*, *Times-Herald* and *Northern Virginia Sun* and from less-remembered papers: the *Arlington Daily*, *Columbia News* and *Arlington Chronicle*. The *Sun* had a column, "The Club Woman Speaks in Arlington," featuring the countywide club and counterparts in neighborhoods like Clarenford, Lyon Village, Lyon Park, Waycroft, Williamsburg and Ashton Heights.

The all-Arlington club's organization included committees (or departments) for membership, welfare, publications, publicity, programs, civic affairs, gardens, "fine arts," "home" and interclub relations.

Volunteers entertain troops at a Methodist church. *Woman's Club of Arlington.*

Perhaps its most impressive time came during World War II, when the women worked on salvage campaigns and promoted war bonds—including at a big rally at the Buckingham Theater. The club's recreation center at Clarendon Methodist Church offered grateful troops on leave ping-pong, piano singalongs, books, refreshments and dancing.

For its first quarter century, the Woman's Club of Arlington met at private homes, Arlington Hall and Trinity Episcopal Church. But it eventually became the only woman's club in the county to own its headquarters. One husband deeded land at 1012 South Walter Reed Drive, which, despite initial opposition from the planning board and neighbors, was traded in 1956 for four tracts at Buchanan and South Seventh Streets. Total cost of the headquarters was $52,000.

From the new building, the women created a "Teen Town Club" for service families as well as the South Arlington Cotillion. They started a library that grew into the Columbia Pike branch and in the 1970s supported Gulf Branch and Long Branch nature centers. The women later adopted Barcroft and Randolph Elementary Schools. In 2006, they provided midwife kits to Kenya.

The club's peak membership reached 167; it is about 30 today (plus 10 inactive). It is moving to evening events to attract working women.

May its future be as bright as its past.

UPPITY LYON VILLAGE

The most contrarian neighborhood in Arlington? Try Lyon Village.

Sophisticates there have tried the patience of many in government over the past century. They've gone to court and blitzed county hearings on issues ranging from collective funding of their community house to residential encroachment from Clarendon's re-zoned restaurants (the ones disgorging those drunk millennials) to the 1920 bid to secede.

"We are considered to be a pain in the ass because there's big development going on, and we have a very active civic association," said Martha Moore, a retired management consultant who's been active in Lyon Village for more than thirty-five years. In April 2016, she was awarded the Sun Gazette Cup for volunteerism by the Arlington County Civic Federation.

Moore helped me through the disputatious history of the Arlington neighborhood listed in the National Register of Historic Places.

Martha Moore often speaks for her neighborhood. *Charlie Clark*.

Lyon Village was formally developed in 1923 on the nineteenth-century suburban retreat and farmland owned by Robert Cruit. Enter Frank Lyon (1867–1955). The onetime newspaper editor from Petersburg, Virginia, was a Georgetown law graduate who made a career with the Interstate Commerce Commission. He built himself a fine place off Old Dominion Drive (now Missionhurst). He made a bundle developing Lyon Park before he turned to subdividing lots on the 165 acres between Lee Highway and Wilson Boulevard.

That set in motion decades of construction of fancier and varied homes laid out on the natural flow of the land, Moore noted. Many were colonials built in the late 1930s by German immigrant Frederick Westenberger, who was profiled in 1993 by his Key Boulevard neighbor Alan Ehrenhalt. Lyon Village gained a vibrant woman's club and civic association, which was instrumental in the new street-naming system in 1934, followed by the first Arlington post office, in Clarendon.

But Lyon omitted one thing. The original sales agreements required him to put aside money for a community house and provide the land. He didn't

follow through. So in the 1940s, Lyon Village activists filed suit, and the Virginia Supreme Court backed them. After funds were raised via hayrides and square dances, Moore said, the center finally opened in 1949.

Modern issues continue to cast Lyon Village as the "crybaby neighborhood," said Moore, who is compiling letters, bulletins and directories for a local history. In the 1970s, some resisted Metro because they feared it would bring in burglars and cut-through traffic (Lyon Village has some of our most restrictive owner-only parking).

When Clarendon's Vietnamese restaurants gave way to pricier mid-range chain eateries, there were cries of "Keep Clarendon gritty," Moore said. Outdoor patio bars serving until 2:00 a.m. alongside private homes caused tensions, though the alcohol problem has improved, she said. "It all made us very vigilant."

It was only when Metro was established that Lyon Village homes rose in value. "They're not great for aging, and the only way to expand them is up, not out," she said.

At one point, Moore recalls musing to the late county board chairman Jim Hunter that Clarendon/Lyon Village should secede. It had already been tried, he noted, referring to the 1920 application for an independent charter by early Clarendon denizens. (Virginia's Court of Appeals said no, calling Arlington "a continuous, contiguous and homogeneous community.")

Moore strives "not to be negative" and works with county staff. But "it was particularly galling when another neighborhood complained—about us complaining."

ARRIVAL AND DEPARTURE OF THE VIETNAMESE

Decades before Clarendon became the pub crawl mecca for Arlington twentysomethings, it was home to "Little Saigon." Though only a few Vietnamese restaurants remain, many locals recall the era from 1975 through the 1980s when Clarendon—long Arlington's quasi-downtown—was dramatically altered and dubbed "the Mekong Delta" by the press. (As Arlington absorbed the big migration following the Vietnam War, cynics called Wilson Boulevard "the Ho Chi Minh Trail.")

Memories of this welcoming chapter in Arlington's history were shared at Arlington County Central Library on May 8, 2014, in a talk the Arlington Historical Society put on to showcase three Arlingtonians touched personally by the Vietnamese arrival.

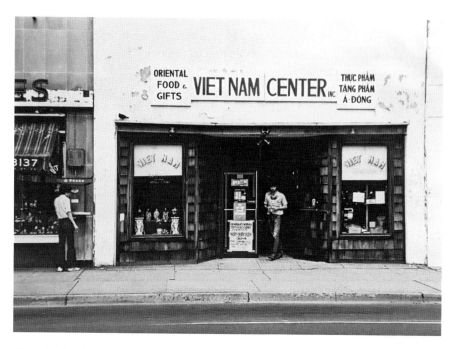

Clarendon's strip of Vietnamese shops has scattered. *Kim O'Connell.*

Kim O'Connell, a freelance writer and preservation advocate whose mother was a Vietnamese war bride, showed photos of Little Saigon's long-gone mainstays: Café Dalat, Vietnam Center, Saigon Market, Saigon Souvenirs and Queen Bee. "I recall the sights and smells of the stores my mother shopped in while, as a nine-year-old, I sat on a crate with my coloring book," she said. O'Connell was fond of the Pacific Oriental variety store, which sold food (oh, the fish sauce!) and fabrics while offering billiards and a Vietnamese band called the Uptights.

Why Arlington? Our county became "a household name in Vietnamese refugee camps," she speculated, because of its proximity to the capital and our cosmopolitan population. (Many among the 230,000 Vietnamese who came to the United States between 1975 and 1980 settled in California, Texas and Indiantown Gap, Pennsylvania.)

As mixed luck would have it, Clarendon had fallen into disrepair as streets were torn up for Metro construction, driving away mom-and-pop businesses, O'Connell said. "As the county struggled to achieve what newspapers called revitalization through Metro, the timing was perfect—landlords needed tenants, and the Vietnamese needed low rents."

They arrived in two waves: in 1975, when the Communists took over Vietnam, and in 1978, as boat people fled oppression.

"You had to have someone vouch for your financial viability or have a sponsor," O'Connell explained. Complaints about the burdens of taking in the Vietnamese were common in letters to the editor; a Gallup poll in 1975 showed that 54 percent of respondents were against opening the doors to them.

But Arlington set up an immigrant integration center at Page School (now Science Focus) and began staffing Vietnamese-language speakers. For the night's two other panelists, the payoff was immeasurable.

Anhthu Lu, sixteen when she left Vietnam in a boat in 1975, recalls being scared at speaking no English. Students in her Fairfax schools were not friendly, and she was "last picked for the teams," she said. She'll never forget the delicious taste of her first hot dog. Recalling one Christmas when the only family present was a Barbie doll, she now gives toys yearly to the Salvation Army. That special "meeting place" on Wilson Boulevard was "like Fifth Avenue in New York."

Thien Huong, raised in Vietnam in a house with a pool, left abruptly in a cargo plane. She felt welcomed by her teachers in the English for Speakers of Other Languages program at Key Elementary and Swanson Middle School. Her family survived on housing grants, said Huong, now in information technology at Deloitte. "I happily pay taxes now because we received so much."

Little Saigon dispersed beginning in 1982 after landlords raised rents by 30 percent. Many businesses ended up in Falls Church's Eden Center. O'Connell hopes to persuade Arlington to honor Little Saigon by erecting a historical marker.

VENERABLE CHURCHES

My neighbor gave me the program St. Agnes Catholic Church prepared to celebrate its eightieth anniversary in Arlington as 2016 ended.

The detailed history of that august body on North Randolph Street in Cherrydale describes how founders broke ground in June 1919. The resulting building (followed by a succession of modernized replacements) officially established its own parish in 1936. With three hundred congregants, St. Agnes became flush enough to add its Catholic school in 1946, later expanding to grades one through eight

and passing the first class on to a new Bishop O'Connell High School in 1957.

Those tidbits inspired me to sketch a history of religious community building throughout Arlington going back two centuries.

Arlington's first church was the Chapel of Ease of Arlington Plantation, built in 1825 by George Washington Parke Custis for use by family, neighbors and slaves. It was burned by Union troops during the Civil War, but the site is marked by a plaque off Columbia Pike and Orme Street near the Sheraton Hotel.

For much of the eighteenth and nineteenth centuries, the Episcopalians who dominated rural Arlington traveled to Christ Church in Alexandria or THE Falls Church, which explains our iconic Glebe House on North Seventeenth Street, built in 1820 on land that supported the rectors of both.

Our oldest active church is Mount Olivet United Methodist at Glebe and North Sixteenth Streets, its cemetery dating to 1854. Walker Chapel at Old Glebe and new Glebe Roads spun off from Mount Olivet, and though its sanctuary didn't open until 1876, its graveyard dates to circa 1848. Hunter's Chapel Methodist at Columbia Pike and Glebe Road was destroyed in the Civil War, so South Arlington Methodists attended Trinity in Alexandria (founded in 1774).

The African American Calloway United Methodist Church on Lee Highway uses the slogan "Welcoming. Growing. Connecting. Since 1866." When the postwar Freedman's Village grew up near Arlington House in the 1870s, it spawned Mount Zion (still going in Nauck) and Mount Olive (in the Arlington View neighborhood). First Presbyterian in Ballston came together in 1872.

In the twentieth century, religious bodies fruitfully multiplied. A 1924 directory cited by historian C.R. Rose showed thirty-eight churches. There were eleven Methodist churches, eleven Episcopalian, six Presbyterian, three Catholic and ten black churches. Clarendon Methodist assembled in 1901, and the Baptists weighed in with Cherrydale Baptist on Lorcom Lane in 1913. Arlington's first Catholic church, St. Charles Borromeo, assembled in 1909, followed in 1912 by Rock Spring Congregational. The First Church of Christ, Scientist, now on McKinley Road opened in 1916.

Episcopalians expanded again: St. George's began in 1908, St. John's in Glen Carlin in 1919, St. Mary's in 1925, St. Michael's in 1945, St. Andrews in 1950 and St. Peters in 1961.

World War II brought a slew of new steeples, including Westover Baptist and Resurrection Lutheran on Washington Boulevard in 1940. Then in

1945 came Our Lady Queen of Peace, whose South Arlington congregation is Catholic and interracial, St. Thomas More and the Unitarian Universalist Church at Route 50 and George Mason Drive.

Our oldest Jewish congregation is the Conservative Etz Hayim on Route 50, dating to the late 1940s. We can't neglect the Kingdom Hall of Jehovah's Witnesses temple on Williamsburg Boulevard, two Mormon entities, two Seventh-day Adventist bodies, the Bangladesh Islamic Center on South Nelson Street and Arlington Metaphysical Chapel on Wilson Boulevard.

Today, ninety houses of worship dot Arlington, according to Churchangel. com. Baptists have seventeen, followed by Methodists with fourteen. My once-dominant Episcopalians are down to eight.

DEMOCRATS IN EXILE

I dined in April 2015 with some Arlington "Democrats in exile" at a retirement community.

The gang of six senior citizens share decades of political savvy and commitment—the only problem being that their home at Goodwin House-Bailey's Crossroads is one hundred yards into Falls Church. That renders them ineligible to vote and affect the Arlington battles they loved so well.

"It's a sore spot," said Ann Yarborough, a Washington-Lee High School graduate and daughter-in-law of Texas senator Ralph Yarborough who has volunteered in Arlington's electoral registrar.

"All of us felt it was a considerable sacrifice but were willing because Goodwin House is so nice," said Bill Bozman, the widower of the longtime county board member Ellen Bozman, who chaired Arlington's United Way and Red Cross.

"We all know Goodwin House leans Democratic, but we don't get into political arguments," said Peg Lorenz, a civil rights activist, candidate driver and events "kitchen crew" leader. "But Democratic politicians love coming" to Goodwin House, which, though nonpartisan, is a voting station and venue for community forums. "One reason for Arlington's activism is its small size," Lorenz added. "It's not hard to get to know your leaders."

Most of these exiled Democrats arrived in Arlington in the 1940s or 1950s, when the flood of postwar federal employees was challenging the old Virginia, segregationist machine of Harry Flood Byrd. The "Save Our Schools" campaign pressed for taxpayer investment in schools as

County political passions often leaned Democratic. *Charlie Clark.*

many Arlington-based federal workers sent their kids to D.C. schools. (Yarborough displayed a bus token from that era reading "Serving our students.")

The Democratic-dominated but nominally nonpartisan Arlingtonians for a Better County provided a way around the Hatch Act for federal employees who wanted to fight Byrd, noted Jack Cornman, an aide to U.S. senator Phil Hart (D-MI), a housing activist and strategist for campaigns of Joe Fisher and Joe Wholey. "We would talk across party lines except on the race issue," Cornman said. Conservative Chevrolet dealer Bob Peck was the Dems' favorite to accuse of dirty tricks.

Lucy Denney cut her teeth in the 1967 county board race in which the Democratic team of Fisher and Jay Ricks knocked off Republicans Hal Casto and Les Phillips. She said Arlingtonians "used to disagree and work things out and compromise. Today's board is less collegial."

All agreed that the most effective Arlington pol was Ellen Bozman. "Ellen ran her first campaign as an independent, and her base was the League of Women Voters," said her husband, Bill.

Denney's husband, Jerry, recalled the time the Bozmans' kitchen team offered to make a salad for an event but had to dispense with lettuce due to the farmworkers' boycott.

Donna Cornman, a longtime precinct coordinator, remembered Democrats stretching a single turkey into tetrazzini for one hundred at a fundraiser, where typically donors not only paid for food but helped with trash and cleaning up.

"The press never understood the politics of Arlington," said Jack Cornman. "They thought we had a machine because we turned out

voters in all kinds of weather. But there was no patronage under the county manager form of government. All you got was appointments to committees and commissions that kept you up late."

One highlight, said Lorenz, was when Joe Wholey lost a 1992 primary for state delegate against fellow Democrat Judy Connally. "Wholey led a caravan to Judy's house to congratulate her. That's the Arlington Way."

THE GULF BRANCH NATURE CENTER AT FIFTY

In June 2016, we marked the fiftieth anniversary of one of Arlington's noblest out-of-the-limelight institutions: the Gulf Branch Nature Center.

I've long maintained a personal relationship with that contemplative haven near my boyhood home. For thousands, Gulf Branch embodies Arlington's visionary environmental progressivism—a movement that today finds parks competing for land against schools, affordable housing and fire stations.

The nature center's image as a "jewel of smart growth" is a reason it was celebrated at a June 2 symposium at the central library put on by our county's parks protectors, followed by a June 12 outdoor party on-site in the woods off Military Road. (It featured high school kids in costume impersonating Hollywood silent screen royalty—actress Pola Negri, who rented the building in the 1930s, and paramours Rudolf Valentino and Charlie Chaplain.)

Among the impresarios was Duke Banks, vice president of the Friends of Gulf Branch Nature Center. "Gulf Branch established a precedent of finding a cottage along a stream," he said. "It was birthed in the 1960s" when the county sought green space to offset coming commercial development of the Rosslyn-Ballston corridor.

My Gulf Branch memories include pulling tadpole eggs from the creek and hiding in the woods to smoke. As a twelve-year-old, I delivered the *Washington Post* to the cottage's last private owner before the county in June 1964 bought it for $135,000.

The larger stage for the center's creation was set by the incipient environmental movement of the early 1960s, said naturalist Jennifer Soles. A National Park Service commission on outdoor recreation recommended collaborations by local, state and federal governments. Arlington's planners incorporated open space in a land-use plan.

Teen thespians impersonate silver screen royalty at Gulf Branch. *Charlie Clark*.

The 1960 elections brought Tom Richards to the county board. An air force intelligence cartographer and hiking enthusiast, Richards recalled that his campaign tapped into a "consensus that community planning was not being well done."

In 1963, the board began applying for federal matching funds to acquire dozens of acres around Gulf Branch. That came as Interior Secretary Stewart Udall was creating open space and trails along the Potomac, the George Washington Memorial Parkway and Four Mile Run.

Boy, did Gulf Branch pay off. The center grew to offer 290 programs for children and the public in 2015, Soles said. Sights for kids ages one to ninety-two include the caged Ms. Owl, the indoor-outdoor beehive, a pond surrounded by labeled flora, the blacksmith shed with skilled volunteer craftsmen and the Robert Walker house showing rustic domesticity in nineteenth-century Arlington.

In February 2009, during the great recession, county manager Ron Carlee proposed a budget with $23 million in cuts. Gulf Branch would have closed, which is why Friends of the Gulf Branch Nature Center was formed.

Looking back, county board member Jay Fisette said, "The county manager proposed many creative and controversial cuts and consolidations. I think this was meant as a serious proposal during difficult budget times. Ultimately, while dozens of staff positions were eliminated overall, the county board continued to fund Gulf Branch at a somewhat reduced level. Residents strongly advocated for it and committed to generate private funds to assist with future operating and capital costs."

Retired homeowner Karl Liewer, whose Military Road house is surrounded by nature center land, donated his easement to the Northern Virginia Conservation Trust to protect against development in perpetuity.

"It's been here long enough that people who came as kids now bring their grandchildren," said naturalist Soles. "Some things haven't changed in Arlington, and it's nice to have places you can connect to your personal history."

SPORTS PAGE: OLD OAKEN BUCKET

Arlington has many historic ties with Alexandria, but perhaps most visceral for those of the right age is the decades-long football rivalry between Washington-Lee High School and its former Alexandria counterpart, George Washington High.

On November 18, 2014, I looked in on a reunion of players and fans of the Old Oaken Bucket Thanksgiving Day gridiron match, which drew thousands to the bleachers annually from 1935 to 1968.

"It was the rivalry that put northern Virginia high school football on the map," I was told by reunion co-organizer Greg Paspatis, a labor-of-love sports historian who, at fifty-four, was easily the youngest in the crowd of one hundred that included a pair of Arlington sports celebrities.

During reminiscences by a panel at Alexandria's Old Dominion Boat Club, the walls were hung with displays of school jackets and sepia team photos from the "leather helmet, no-facemask era," as characterized by GW alum Dave Beach. He was selected as the most valuable player as a fullback and linebacker for the Presidents (shortened by headline writers to "Prexies") in the early 1950s.

(Games between the two high schools actually began in the 1920s before giving way to the Thanksgiving Day extravaganza that ended in the late '60s because of new regional playoffs and GW's eventual conversion to a middle school.)

Virginia high school football was huge in the 1950s and '60s. *Charlie Clark.*

Former Alexandria mayor Patsy Ticer, a cheerleader for GW in the early 1950s, teared up while recalling the importance to the community of the Old Oaken Bucket contest, which often drew between ten thousand and twelve thousand spectators.

Making a rare appearance was Reggie Harrison (Washington-Lee, class of 1969), the onetime Pittsburgh Steelers running back who was a hero in the 1976 Super Bowl. He humbly recounted his six touchdowns in the 1968 turkey-day game, which the Generals won, 46–6.

But the clear highlight of the Old Oaken Bucket reunion was revisiting the feat of Wayne Ballard in the 1956 contest, which *Washington Post* sportswriter Tom Boswell called the most memorable school game in northern Virginia history.

On that freezing Thursday in Eisenhower-era Alexandria, undefeated W-L found itself tied with the Prexies, 0–0, with two seconds to play. Quarterback Wayne Ballard, who at the reunion spoke from the audience, attempted a forty-three-yard field goal with the disruptive wind at thirty miles per hour. Radio audio and home movie footage of what happened next drew groans from many in the 2014 crowd as they relived their shock.

The ball Ballard kicked hit the crossbar, bounced up and finally fell to the opposite side. That gave W-L a 3-0 victory, along with the county, regional and state championships (as well as an end to GW's recent victory streak in the series). One GW back who had stood near the goalposts for the field goal recalled wanting to swat the ball back.

Ballard would see his photo in *Sports Illustrated*, go on to play at the University of Virginia and then sell insurance in Arlington. (Retired, he still attends W-L games.) One GW alum recalled the time in later life when

Ballard called him on business and began, "You probably don't remember me." The GW alum cut him off: "Oh, yes I do."

Thanks to Alexandrian Joe Adamoli, I got a copy of the rare video of that game, and readers can hear audio on YouTube.

In the three decades of the rivalry contest, the Arlington boys won twenty-one Old Oaken Buckets, versus twelve for Alexandria, with three ties. The attachments between the two hometowns live on.

THE ARLINGTON SONG

Yes, Virginia, Arlington has an official song.

In 2015, a friend passed me a copy of the sheet music for "Arlington," written more than four decades ago by the late Ernest K. Emurian, pastor of Cherrydale United Methodist Church.

I'd wager it's sung or even recalled by very few of today's august county residents, though there is a movement afoot to put the hymn back in the public consciousness.

Admittedly, Emurian's "Arlington" is not the most famous composition to emerge from our local streets. That stature belongs to Julia Ward Howe's "Battle Hymn of the Republic." Those immortal lyrics came to her in 1862 when, as an abolitionist, she visited Fort Ramsay in Arlington (now the Upton Hill Regional Park on Wilson Boulevard). On the carriage ride back into Washington, she heard troops singing "John Brown's Body."

Reverend Ernest Emurian with scout George Dodge. *Dodge family.*

According to the regional park's website video narrated by newsman Roger Mudd, a friend suggested to Howe that she compose new lyrics. She did so that very night, and they were published in February 1862 in the *Atlantic Monthly*.

Fast-forward to 1970. Pastor Emurian, a musician of Armenian descent who spent nearly twenty years at Cherrydale Methodist on Lorcom Lane, was moved to write the Arlington song's words and music. After a bland

introduction about love of hometown, the song delivers a chorus sung "slowly, stately":

On a northern Virginia hillside, where Potomac's waters flow;
And where heroes lived, other heroes lie 'neath the crosses row on row;
And a mansion of stately splendor tells of battles lost and won;
And adds her name to the nation's fame, the name of ARL-LING-TON.

Among the many Emurian fans still active at the church is Virginia Dodge, wife of the late Arlington judge Thomas Dodge. "He always said any place worth living in is worth singing about," said Dodge, who has sung Emurian's hymn regularly with the teenage social group Job's Daughters. Emurian, who composed eight published hymns and wrote many books, once staged a drama based on Da Vinci's *The Last Supper* that is produced around the country.

It was in the fall of 1970 that Dodge's daughter Mary and twenty-two friends donned colonial dress and performed Emurian's Arlington song for the county board. Chairman Ned Thomas gave the girls a copy of Eleanor Lee Templeman's county history after the board official adopted the song—it was printed and circulated by the chamber of commerce. The girls' photo appeared in the *Northern Virginia Sun*.

Emurian, who served at churches in Lynchburg and Portsmouth, also wrote a song titled "Virginia Is for Lovers." He died in 2004 and is buried at Columbia Gardens.

I discovered I wasn't the only sleuth tracking the story behind the Arlington song. Peter Golkin, an ace public information officer for the Arlington Public Library, in early 2016 chanced upon a copy of its sheet music at a flea market. "I don't think many people remember it," he told me. Golkin checked the library's Center for Local History and found forty copies moldering in a folder.

Golkin's own history of the song was just published on the county website, and in March 2016, a group (myself included) gathered in the studio of Arlington Community Media to record a rendition of the song, which ends:

From the mansion one can gaze across the river;
Into Washington, D.C., whose memorials and monuments remind us;
Of those who have lived to make men free.

OPENING THE SWIMMING POOLS

A poolside reverie in the summer of 2015 prompted me to ponder the state of swimming in Arlington County.

The county board's ambitious plan for a world-class swimming complex is on hold, pending the county manager's rethinking the possibilities for the Long Bridge Park site following harrowingly high bids from contractors. After blasts from critics about overspending, the county board in March 2015 directed staff to broaden civic engagement and explore possibilities of sponsoring partnerships.

Backers of the Pentagon City neighborhood aquatics center have stressed the need to compete with neighboring jurisdictions in the quality-of-life sweepstakes with Olympic-scale offerings. They advertise the customized water therapy tools for seniors who have trouble getting in the three public high school pools due to limited hours.

I thought of another selling point, even though, speaking from the comfort of my membership at the Overlee pool, I am unlikely to use a Long Bridge Park pool myself.

A mental survey of Arlington's major public and private pools highlights some interesting geography. Our earliest public swimming was done in the Potomac early in the twentieth century at a site near today's Fourteenth Street Bridge called Arlington Beach (photos and advertisements of which survive).

Racial segregation and the high costs of building and running (and joining) a swimming pool meant that most of the subsequent facilities were private. The Army Navy Country Club off of South Glebe Road (established in 1924) had complicated membership categories for military and civilians; today it has four pools.

Up north, Washington Golf and Country Club has had a pool at least as far back as 1936, when its old clubhouse burned down. It expanded its main pool in 1958.

Arlington's postwar boom brought the subdivision membership associations. Arlington Forest got there first in 1954, with its handsome pool nestled below Carlin Springs Road. Dominion Hills Pool on Wilson Boulevard wrote its bylaws in 1955 and built on the site of the nineteenth-century Powhatan Springs. My own Overlee Community Association formed on Lee Highway in 1957 and became a regional swim competition powerhouse.

In 1959, the Northern Virginia Aquatic Club—Arlington's first indoor membership pool—was founded by coach Stan Tinkham on Lee Highway

in lower Cherrydale (my parents sent me there). It closed in 1988. Donaldson Run's pool off Military Road opened in 1958.

Not to be outdone, the Catholics at the Knights of Columbus opened a pool hidden from the street on Little Falls Road. (Its swim team is named the Holy Mackerels). And the Fort Myer–Henderson Hall base boasts four pools for military families (in 2012, it opened its lanes to government employees).

The big victory for public swimming opportunities was the opening in 1973 of taxpayer-funded pools at Yorktown, Washington-Lee and Wakefield High Schools. In 1979, the largest non-membership public pool opened at Upton Hill on Wilson Boulevard. The pay-per-swim club is run by the Northern Virginia Regional Park Authority, which also offers mini-golf and a batting cage.

Then there are the Arlington families who sneak across the McLean border to join Chesterbrook or Tuckahoe pools.

The upshot? Our natatory options are tilted heavily to north Arlington. South Arlington gets only the part-time public Wakefield pool and the members-only Army Navy Country Club.

ONE HUNDRED YEARS OF THE CIVIC FEDERATION

"When you turn on your taps and flush your toilets, you have the Arlington Civic Federation to thank." So read the earthy history compiled in tribute to that sometimes-cacophonous collection of eighty neighborhood entities celebrating its 100th anniversary in April 2016.

The Civic Federation gala banquet at the Rosslyn Holiday Inn reconvened 260 longtime activists, leaders, past and present county and school board members, lawmakers and top county officers.

County manager Mark Schwartz praised Arlington's "oldest countywide organization" for its "positive role in every major issue we face." He called Arlington "the best county in the country." (Anyone beg to differ?)

The agenda included awards and lots of thank-yous, though some diners murmured rather than provide undivided attention (that's volunteer life).

Federation president Stefanie Pryor toasted "100 more years of the Arlington Way" and said the crowd deserved a "pat on the back for knowing your neighbors, not just their email addresses."

Arlington was technically still Alexandria when the federation was hatched in 1916, four years before Richmond voted for separation. The population

of sixteen thousand lacked the sewers we take for granted today. Within a decade, six neighborhood associations—Bon Air, Cherrydale, Clarendon, Hume, Lyon Park and Lyon Village—joined forces with the Organization of Women Voters. They persuaded fifteen hundred households to pledge twenty-seven dollars apiece so that Arlington could become, as the *Evening Star* reported in 1926, America's first county with its own water supply.

The federation worked with the general assembly, Congress and the Army Corps of Engineers to access the District of Columbia Reservoir. It held a public forum at the courthouse and a committee meeting at the new Washington-Lee High School, eventually winning over skeptics from Lyon Village (who've long marched to their own drummer).

Activists collected 2,072 signatures and won passage of water bonds by a ten-to-one ratio. The water flowed on November 3, 1927. There followed decades of expanding connective plumbing until 1962, when Arlington's last privies were covered over.

Reviewing historical highlights in 2016, state senator Barbara Favola heralded the 1930 conversion to the county manager form of government ("Planning is what we do best," she said). Building the Pentagon in the early 1940s "had a huge impact culturally, socially, economically." In the early 1950s, the nonpartisan Arlingtonians for a Better County allowed federal workers to get around the Hatch Act to resist Virginia's "Byrd Machine." Arlington became first in the state to desegregate schools.

The 1970s brought the first tax relief for the elderly, the state's first group home for people with disabilities (in Ballston) and the Long-Range Planning Commission, Favola said. The '80s brought Arlington's arts incubator and commitment to affordable housing.

The star of the evening may have been "the newly chic Shirlington neighborhood," as it was labeled by WETA president Sharon Percy Rockefeller, who appeared via video. WETA CEO Rick Schneider was there to receive the federation's Centennial Historic Achievement Award on behalf of the late station founder Elizabeth Campbell.

Eric Schaeffer, the globally renowned Signature Theater artistic director, referred to himself as the "self-appointed mayor of Shirlington" in commending the federation.

"Long before you were the powerhouse you are today, I was a delegate," Favola said of the august body. It has been there to "harness our talents, fears and dreams. Though we haven't always agreed, it delivered," she said. "Dream big, and don't be afraid of change."

4

LOFTY MILESTONES

VIRGINIA'S FIRST SCHOOL INTEGRATION

Arlington Public Schools staged a reunion of sorts on February 2, 2016, assembling citizens who'd once viewed one another only across the racial divide.

The panelists' talk at the Stratford building marking the fifty-seventh anniversary of our state's school integration was historic, educational and touching. Three of four "local heroes," as they were called by school board chair Emma Violand Sanchez, returned to their junior high, one for the first time since the drama nearly six decades ago. Gravitas for the evening commemoration (following daytime discussions for students in the H-B Woodlawn progressive secondary school program) came from Senator Tim Kaine via video.

The broader picture—fascinating political tactics used by black and white Arlington activists to overcome Virginia's "massive resistance" to integration in the 1950s—was driven home by the 2001 Arlington Educational Television documentary *It's Just Me*. It showcased how white liberals risked professional reputations to link arms with African Americans with whom many had had virtually no social contact.

It wasn't that blacks coveted having their kids learn alongside whites, one black parent said. They just wanted the best-paid teachers and the most effective learning tools. Blacks resented being bussed past Washington-Lee

High School to South Arlington and being excluded from Bernie's Pony Ring at Lyon Village.

Before the courts and governor ordered integration in 1958, Arlington prepared. Four black seventh-graders were selected out of thirty based on achievements and psychological makeup.

"I never asked why my parents wanted me to do it," recalled Michael Jones.

On February 2, 1959, Lance Newman remembered, Jones's "father dropped us off on Old Dominion Drive where there was a ton of cops." After a stop at the principal's office, the four were split into pairs. When Newman arrived in math class, "the door opened and there was tension and silence as they introduced us." When the period changed, he recalled "a mass of humanity, all white, and curious stares."

Ron Deskins was flummoxed that a reporter camped at his house that morning. "I didn't expect violence like Little Rock," he said, acknowledging the white student volunteer guides who ate lunch with the newcomers.

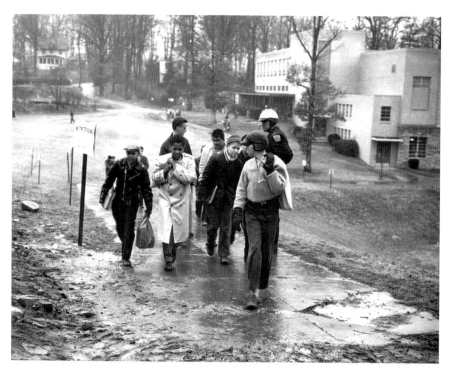

Stratford's integration was a collective effort. Washington Star, *District of Columbia Public Library*.

"There were no public displays of affection or animus," but a few people later "made it their business to try to make our lives miserable but didn't succeed."

None of the four twelve-year-olds realized the national significance of their action. They viewed it like a day job, after which they returned to real friends on the neighborhood playground.

What they couldn't know was that the Stratford staff had also prepared. An advance assembly was called to ask which teachers would host the pioneer students. "I'm proud I said yes, but to me it was just another day," recalled former teacher Martha Ann Miller, age 104. At a neighboring house, nervous parents gathered to monitor the action.

All four children went on to graduate from Washington-Lee. Newman got a degree in electronic engineering in California and worked for Aerospace Corporation. Deskins dabbled in college and spent thirty-four years as a Fairfax County fireman. Jones attended Howard and Fordham Universities, did an army stint in Vietnam, sold insurance and worked for the CIA.

Newman confided that he prepared for English class by writing his best "Alfred Lord Tennyson" style. But after seeing the quality of his classmates' work, he realized "they were just as dumb as I was."

WHEN WAKEFIELD HIGH SCHOOL INTEGRATED

A most local of local histories is the personalized recounting of the *Integration of Wakefield High School*.

The paperback published in 2014 by the scholarship-giving Wakefield High School Education Foundation offers powerful memories of one of Arlington's historic transitions. Some of the memories are so painful for participants that it took decades for them to resurface.

Organized by former school board member Conchita Mitchell (Wakefield, class of 1966) and Millie Mohler Lawson (class of 1963) along with fellow alumni and current sociology students, the book printed with a cover in Wakefield's "Warrior Nation" green offers intimate testimony and faded black-and-white yearbook photos.

The text captures drama set in motion by the national, state and local forces of school desegregation—and the challenges and resistance thereto—when the all-black Hoffman-Boston High was blended into decade-old, all-white Wakefield.

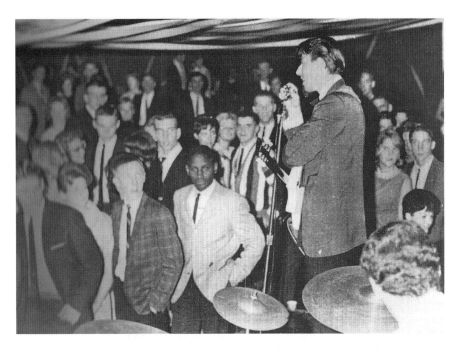

The 1964 integrated homecoming dance. *Courtesy Wakefield High School Education Foundation Incorporated.*

The 250 kids from Hoffman-Boston went from a class of fifty-five to one of four hundred. "Because the black population in Arlington was small, the teachers had taught many members of families—sisters, brothers, cousins," according to the introduction. "They had high expectations and accepted no excuse for bad behavior."

Principal George Richardson declared, "We weren't preparing our students for Wakefield. We were preparing them for life." When Richardson was made deputy principal at Wakefield, he got along with his direct boss but "did not feel it was as easy to work with" the superintendent of schools, Ray Reid, who he felt was "less accepting and collegial."

Isaac Brooks (class of 1965) recalls feeling that, academically, "much of what was covered at Wakefield had already been covered at Hoffman-Boston." He spoke of being uncomfortable when Wakefield's white kids were curious to touch his hair.

Preston Green (class of '67) remembers a metal-shop teacher apologizing because he "wasn't sure how to teach blacks." A white kid in electronics class said he didn't like blacks—his parents were in the American Nazi Party. Walter Reed Drive, Green recalls, was the dividing line between the races.

Sports was the milieu for much tension; a 1956 Virginia Assembly resolution banned interracial teams. Wrestler and football player Larry Randall (class of '65), the first black student on a Wakefield sports team, recalls "hearing racial comments and insults from the stands at Fairfax and Falls Church high schools."

Clayton "Cookie" Powell (class of '65) recalls basketball referees calling imaginary fouls on black players; the coaches would not complain.

Fascinating memories from white alumni were also offered. Glen Bayless (class of '64), whose father ran for county board on a desegregation platform in 1953, remembered receiving hate calls. He played on the basketball team that went to state finals his senior year and had already known black teammates through previous "illegal scrimmages."

Two Jewish brothers, Jim and Howard Bregman (classes of '60 and '64, respectively), grew up in a white family that operated a grocery store serving black customers in Green Valley. They "played with and visited with the homes of their black neighbors but were bussed out of Green Valley to go to school." The Bregmans were disappointed when the Nauck community produced a photo history without mentioning their store.

The book offers a useful timeline of desegregation. But the true human flavor comes across when the narrative follows these pioneers into adult life, where they meet a panoply of fates.

These alums must be heartened to see the current student body at Wakefield: 16 percent white, 23 percent black, 10 percent Asian and 48 percent Latino.

Picketing the Country Club

The year 1968 was, like 2016, a politically turbulent one. It was also the year that a group of high school kids (myself included) picketed the Washington Golf and Country Club.

This largely forgotten protest against the Arlington establishment drew plenty of news coverage. When a half dozen people who had marched recently reunited online to recall the details, we agreed that the event inspired change in both the club (we like to think) and, certainly, in the lives of the participants.

The clash began when an African American Maryland woman named Vivien Rowan joined the tennis team at Indian Spring Country

Club. She was the wife of syndicated columnist Carl Rowan, also an ambassador who ran the U.S. Information Agency. As reported in the *New York Times*, *Washington Post* and *Evening Star*, her presence prompted three clubs to quit the interclub league due to "lack of interest." Washington Golf was among them.

As organizer Tom Clark recalled in 2016, "This was a few weeks after the Chicago Democratic Convention, a few before Nixon's election…a few months after the Martin Luther King Jr. and Robert Kennedy assassinations, the Paris demonstrations."

To us, it seemed the world was in turmoil, and youth was called to action. Several dozen Yorktown High School kids from all three classes made plans, alerted city editors and showed up just after the start of the school year, on the morning of Saturday, September 7. As local TV news cameras whirred from across Glebe Road, the protesters chanted and waved posters with slogans such as "Discriminating People Choose WGCC" and "Get a New Racket."

The highlight in everyone's memories was the emergence of white-haired Chevrolet dealer Bob Peck from the club's doors. He stormed onto the lawn and scolded us (something about free association and our need to get a job).

"His face was red as a tomato, and I have to admit it made me nervous," recalled Marguarite Reed Gooden, then the only black student in Yorktown's senior class. "But we all kept cool, never responding!" That game face was particularly hard for Reed, because her father sometimes caddied at the club and she didn't want to get him in trouble.

"Many cars tooted their support, while a few yahoos shot us the bird," recalled John Lorenz, who saved his protest sign for years afterward.

"It was an eye-opening realization that our little neighborhood issue was very much tied to bigger turmoil that was about to bring the country to its knees," recalled organizer Glen Schneider. "It was a pretty jarring realization for a self-absorbed seventeen-year-old living in suburbia. But like everything else we did, there was an element of fun."

Co-organizer Mark Rosenbaum, who was on the school basketball team, said his coach worried he'd get arrested. So the planners met first with Commonwealth's Attorney William Hassan, who said marchers would be fine if they stayed on the sidewalk. Rosenbaum's Jewish parents had also sensed discrimination at the club, so they sympathized, he recalled.

Mary Vandevanter remembers being pleased that Rosenbaum's parents brought fifty McDonald's hamburgers to the protesters, but her own parents "saw it on the news and got pretty steamed."

It was a different era, of course. Few at today's more welcoming country club, where I have friends and have enjoyed much hospitality, remember the picketing.

But to those teenage protesters, it was a first taste of their impact on the adult world.

WILSON PICKETT PLAYED THE SCHOOL GYM

If you saw the musical dramedy film *The Commitments*, you'll recall the motley crew of young Irish rockers awaiting a rumored local club performance by the legendary Wilson Pickett.

Well, for a certain strata of Yorktown High School graduates from Arlington in the late 1960s, that performance became reality. For decades, the Wilson Pickett show in the school gymnasium generated a slew of conflicting memories about the surrounding racial tension, missing proceeds and hardball student politics.

In 2014, I decided it was time to set the record straight. (Because our school's got soul.)

In the fall of 1968, Wilson Pickett was a gravelly voiced Stax Records soul singer famous for such hits as "In the Midnight Hour," "Mustang Sally" and "Land of 1,000 Dances." The notion that a student government in ordinary suburban Yorktown could attract such top talent was a thrill. The booking was also an edgy move for a mostly white student body, a seeming reaching out to black classmates that some students, who preferred other bands, resented as "liberalism."

I was present at the show on the evening of January 19, 1969, watching students leave their chairs to dance in the aisles to Pickett and Florence Ballard (formerly of the Supremes), backed by horns from the Midnight Riders.

Student council secretary Jean Offutt Lewis, now an artist, recently told me that she had greeted Ballard when she arrived looking for her "dressing room," which was the girls' locker room. "One of the perks of being an organizer was getting front-row seats," she recalls. "So after rehearsals, I went home to change. At the concert, Wilson recognized me sitting there, came over and sang to me."

Retired math teacher Wilmer "Whiz" Mountain was one of the faculty who ringed the front of the auditorium to "hold back" anyone approaching

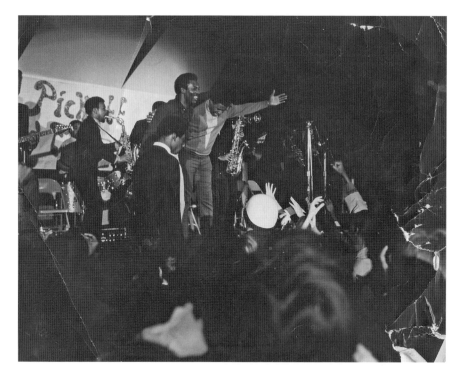

Wilson Pickett at the school gym. *Michael Wilson for the* Yorktown Grenadier.

the stage. "I remember our principal was not too happy with the outcome. It didn't make a lot of money for our school."

Steve Nelson (class of 1970) recalls jumping in his car with buddies after the show to follow Pickett's car across Memorial Bridge "until they stopped and a big, mean guy got out to ask what we were doing. Just going with the Flo, we said."

For clarity on the racial politics, I reached student council president Monty Freeman (now a New York City architect). "The simple truth is that I and some fellow Student Council officers liked Motown and R&B and wanted a soul act. Not everyone involved agreed, and we prevailed. The very few black students that we had at Yorktown then did not factor into the decision," he said. "We did lose money on the concert, which we probably would not have done if we'd booked a more mainstream white band...and we were criticized for that."

Both of the iconic performers went on to the Rock and Roll Hall of Fame. Ballard died a sad death by heart attack in 1976 at age thirty-two.

Pickett, who later moved to nearby Ashburn, Virginia, died in 2006 at sixty-four of the same cause.

But their Yorktown concert legend lives on. In 2013, I was driving past the home of my friend Doug Ammons. He flagged me down and told me to wait. He reemerged and presented me with a black-and-white photograph, taken by Michael Willson (YHS class of 1969), showing wicked Wilson himself, in close-up, in our own school gym.

WHEN WATER ROSE FROM HURRICANE AGNES

In November 2016, I witnessed an online demonstration of a new, real-time flood mapping tool from the National Weather Service and the U.S. Army Corps of Engineers.

The new system, funded in part by Arlington, gives advance warning of rising Potomac waters in D.C. and northern Virginia (including Four Mile Run). Data is derived in part from past events, including the notorious Hurricane Agnes of June 1972—if you lived through it, you, too, have the memories.

Arlington and the swollen Potomac during Hurricane Agnes. *Rick Bethem.*

Agnes involved four days of rains, with 128 deaths in mid-Atlantic states (16 died in Virginia, with damage at $222 million). Richmond was hit hard, Occoquan lost its iron Pratt Truss Bridge, Fairfax lost power for its water supply and rainfall in Chantilly reached sixteen inches.

The Potomac swelled to a point even with the Kennedy Center terrace; a piano floated in its swirling waves. The canal's walls broke in three places. George Lincoln, head of the Office of Emergency Preparedness, said the East Coast flooding was "the most massive in history." Iconic news photos showed President Nixon in a helicopter over Wilkes-Barre, Pennsylvania.

My own memory reverberates from my teenage summer job moving furniture for Newlon's Transfer. In the slosh, we came back to the Nelson Street yard and heard that D.C. bridges were blocked. One of our black crew chiefs, Al Dean Knight, couldn't drive home. My brother and I invited him to sleep on a cot in our home. In the middle of the night, we were awoken by a thunderous crash. The brick retaining wall in our side yard had given way, and a brick came flying through the window in my brother's bedroom, just missing Al Dean's head.

Memories of Chain Bridge with sudsy rapids only feet below were collected by Arlington's Central Library in 2012. They included tales from Joseph Fletcher of McLean, whose family owned Fletcher's Boathouse. His father ordered him to cross Chain Bridge and help stabilize sixteen boats, the only ones left from the eighty they owned.

Arlington was relatively lucky. According to the June 24, 1972 *Washington Star* interview with Washington National Airport manager Bernard McGinnis, crews worked all night putting up sandbags around vaults containing electronic equipment. Amazingly, the Potomac rose to nine feet, not high enough on the twelve-foot sign on a marker, which would have meant it spilled over to runways and shut down flights.

The main obstacle in Arlington was five hours of gridlock on Crystal City's Route 1, packed with traffic diverted from the G.W. Parkway. ABC-7 chief meteorologist Doug Hill recalled in 2012, "There was a shopping center in Arlandria, and the firefighters had to helplessly watch the fires rage because there was no way to get to it." The bridge across Four Mile Run at Walter Reed Drive collapsed.

The damage from Agnes helped clinch Representative Joel Broyhill's proposal for federal money to bolster the Arlandria channel against flooding, a multimillion-dollar project completed in 1977.

It also prompted, in the mid-1970s, Civic Federation president Joe Pelton, who would serve on the Long-Range County Improvement Commission,

to help state delegate Warren Stambaugh gather twenty-five hundred signatures asking the Virginia Transportation Department to replace the one-lane Bailey Bridge over Four Mile Run. That, Pelton told me, was the beginning of the economic revitalization of then-decaying Shirlington. Forty-four years after Agnes, it is one of Arlington's most vibrant—and driest—communities.

150 YEARS ON HALLS HILL

The historically black community of Halls Hill/High View Park kicked off a series of look backs in January 2016 to mark its sesquicentennial (1866–2016).

At the Mount Salvation Baptist Church, I witnessed a stirring program in the company of some two hundred congregants, county board members, Arlington history buffs and one veteran of the 1959 integration of Stratford Junior High, Michael Jones.

The program was anything but dry and dusty. The main event, a local history lecture, was bookended with prayers and gospel hymns ("The Lord Is Blessing Me") and a reading of an 1857 court deposition about a slave named Jenny. She was convicted of murdering the wife of namesake plantation owner Bazil Hall by pushing her into a fire.

Carmela Hamm performed living history in laborer costume, quoting the "crystal stairs" reference in a poem by Langston Hughes and imploring young people to "plant a seed" to preserve their heritage.

Halls Hill, as explained in a handout, was created after emancipation when Bazil Hall sold three hundred acres to former slaves for ten to fifteen dollars an acre, which laborers then worked typically for fifty cents a day.

But the Sunday formal talk was broader. Lauranett L. Lee, founding curator of African American history at the Virginia Historical Society, recalled how, as the only black student in her fourth-grade class, she shied away from history after reading in the Virginia history text that "slaves were happy."

The Richmond-based society that now employs her was founded in 1831—the year of Nat Turner's rebellion—to house the records of "elite white families," Lee said. But thanks to modern technology, her society's Unknown No Longer online database contains thousands of records of Virginia slaves. The original documents are "crumbling and fading, with

Carmela Hamm channels an enslaved narrator. *Kristin Adair.*

chicken-scratch writing," Lee said. "At 5:00 when the society closes, the names stay with me, and I have nightmares about the daily assaults" on enslaved people.

She encouraged youth to "interview your elders, be interested in their lives, take the time" to ask about the days when blacks and whites didn't use the same schools, parks and water fountains. "We've come a long way, and our history is worth preserving. If you don't, it can be twisted."

Only weeks before this event, I interviewed another Halls Hill stalwart, who also grew up attending Mount Salvation. Amelia Edwards, who at eighty-seven continues her late-life career as the school crossing guard for Nottingham Elementary, recalled the decades she spent at 2318 North Dinwiddie Street, a dirt road when Lee Highway was a one-lane thoroughfare. Her father, a longtime janitor at the four-room Langston Elementary School, and her mother raised six children in three bedrooms with no indoor plumbing and an outdoor well.

"We raised our own food—hogs, ducks, chickens, squirrels and pigeons," she told me, recalling growing string beans in the garden and shooting invading rabbits with a shotgun. She and her friends had to take buses downtown to attend black junior high and high schools.

She recalls minor violence—drunkenness among neighbors and cross burnings on the Lexington Street lawn of famed physician to the black community, Harold Johnson. Edwards also worked at the segregated unit at the newly established Arlington Hospital after it opened in 1944 before beginning a federal career at the Government Printing Office.

Recalling the old Halls Hill now that she lives in an apartment in Westover, Edwards said, "We had a good life."

ROOTS OF STUDENT ACTIVISM

In Arlington, budding politicians start young.

In October 2013, one hundred middle schoolers gathered at a H-B Woodlawn high school program for a "teen leadership" exercise in a mock general assembly. The kids researched and debated bills according to Richmond's procedures, telling fellow solons, per the *Sun-Gazette*, that a certain parliamentary ruling was "cool."

What was cool for me was noting that the event took place in the Woodlawn program, itself the creation in part of prodigy student activists I knew in the late 1960s and early '70s. Things back then were more contentious. Before that "hippie high school" was launched in 1971 by Wakefield High School teacher Ray Anderson (now retired but still active in education), it was incubated by a student rights group called the Arlington Youth Council.

In 1969, its big issues were student rights to protest the Vietnam War, read underground newspapers, battle oppressive dress codes and experiment in free-form education. Those youth council presidents were uppity, articulate teens. Among them were James Rosapepe, now a Maryland state senator and onetime ambassador to Romania; Jim Massey, who lived in Phoenix doing real estate and technology startups before his death in 2016; and Jeff Kallen, now a linguistics professor at Trinity College, Dublin. Kallen became the Washington-Lee High School pied piper who teamed with Anderson to found Woodlawn. He also sought to become Arlington's first student school board member.

Our crowd was obsessed with demanding a student smoking court—an issue I'd now say hasn't stood the test of time. But we wanted student views respected, and that proposition took flight.

Nowadays, half of the states allow student school board members, according to the National School Boards Association. In Takoma Park,

Student activists conspiring in 1970. Yorktown Sentry.

Maryland, in the fall of 2013, sixteen- and seventeen-year-olds for the first time had the right to vote in city elections.

Deference to student sentiment, sometimes over adult objections, continues at Woodlawn in the form of the Thursday town meeting. That decision-making forum, open to students, teachers, custodians and parents, "is well attended, depending on the issue," I was assured by the principal at the time, Frank Haltiwanger. "Anyone can put an agenda item outside the main office door," he said, whether the topic is a school dance or overcrowding.

One issue that raised emotions in 2011, Haltiwanger said, was Arlington schools' online parent portal, which was conceived to allow parents the ability to remotely examine their child's attendance, grades and assignments. "The initial reaction from many was that it doesn't make sense to do this for parents before students," he said. So the Woodlawn town meeting folks wrote to the school board; soon, students, too, were in on the portal.

The Arlington School Board has no student member, "but we do have a Student Advisory Board made up of representatives from all high schools," I was told by Linda Erdos, assistant superintendent of school

and community relations. It touches all democratic bases— it meets monthly and is assigned a school board liaison and staff liaison. The advisory board addresses topics submitted by the school board, working with administrative staff on upcoming agenda items while funneling broader student input on "issues of importance."

These teens meet with the school board quarterly and, like all of the board's thirty advisory committees, report to it during a year-end meeting.

I'm as impressed today with Arlington's young activists as I was back in 1970, but I can't help but feel—in this age of helicopter parenting—that most modern teens would find democracy's accompanying policy minutia a bit dull.

Preserving Woodlawn Graffiti

The December 2014 announcement that the storied H-B Woodlawn "hippie high school" program was moving to a new multistory building in upper Rosslyn was greeted with relative equanimity.

Chief among the worries that surfaced was, revealingly, what will become of "the words of the prophets [that] are written on the H-B wall." Among students, staff, parents and alumni, one of the gems of Arlington's forty-four-year-old trust-the-student experiment has been the walls that each graduating class is allowed to paint, sloganize and memorialize with graffiti in the cafeteria and hallways of the Stratford building on Vacation Lane.

Swirling in glorious amateur multicolor are song lyrics from Bob Dylan to the Beatles, poetry and human body prints (added by Woodlawn chemistry teacher Dave Soles when he was a student).

"Not all who wander are lost," reads one testimonial. "We are the merry makers and the dreamers of the dreams." "You can be in my dream if I can be in yours." My daughter, class of 2006, said, "The halls are another classroom, ripe with political debate, literary analysis and impromptu song." (Her writing quoted "Hey Jude.")

As the students' online newspaper, *Verbum Sap Sat*, explains, newcomers to the sixth- to twelfth-grade program sometimes fixate on planning what they will paint on the walls when their turn rolls around. Two years ago, Woodlawn's "town hall" meeting discussed concerns about "censorship" of the wall when some contributors deploy off-color or hurtful language.

The wall began, I'm informed by H-B founder Ray Anderson, when the class of '87 balked at trying to pack the names of all of the classmates

The immortal cafeteria graffiti. *Franci Swisher-Gomez.*

onto a standard-size memory book. Then the class of '88 demanded equal opportunity; since then, additions to the wall have never flagged.

One reason Anderson and successor principal Frank Haltiwanger wanted to keep the tradition alive is to "show we can make the necessary accommodations with the powers that be," said Anderson, who can recall the inscriptions left by his own three children. The agreement with the school board and superintendent stipulates that students won't deface the lockers or ceramic tile that date back to 1950.

The ever-loyal Woodlawn alumni often return and ask to see the wall that, at some seventy-five students per class, has now expanded to more than two thousand inscriptions.

It's easy to see how the Arlington schools' plan to relocate the popular countywide program in a new structure on the site of the old Wilson School presents a challenge.

The good news is that the powers that be are hip. Scott Prisco, Arlington schools' director of design and construction, told me: "It is my understanding that the paintings on the walls from students are a very important part of the school's tradition. This tradition and important history that has been created needs to be preserved in some special way." A most "sensitive and

appropriate response" will be hammered out by students, staff and the building-level policy committee.

A senior in 2012 created a digital record of the graffiti (though a few of the writings have been lost to renovations). Principal Haltiwanger told me that it's not feasible to move the walls themselves; some form of digital reproduction—perhaps a continually rotating video—is one idea being considered. "The move won't take place for five years," he cautioned, "and we just got this news." But the powers that be agree: the H-B wall will endure.

BALLSTON MALL'S PRECURSOR

Arlington's ailing but still centrally located Ballston Common Mall got an economic shot in the arm in November 2015. For frequent users such as myself, the news signaled local history repeating itself.

The county board voted to cough up $10 million for parking and transportation improvements following years of public-private planning. By the next spring, that investment would leverage another $45 million loan to help developer Forest City realize its ambition to re-outfit the surroundings for hipsters of the twenty-first century.

"It's a landmark project because the county has never done a community development bond," I was told by Tina Leone, CEO of the Ballston Business Improvement District. "What I find amazing is that this property has been an economic generator for a couple of generations and will continue to be, in the heart of Ballston."

Nearly seven decades ago, a similar commercial adventure unfolded when the old "Parkington" shopping center was raised with national fanfare. Details were fed to me by some retired Arlington teachers.

Action at the crossroads of Wilson Boulevard and Glebe Road goes back to the eighteenth century in the form of a tavern, market and voting station. But it was during the post–World War II suburban boom, according to a 1951 *Washington Post* illustrated article, when the arrival of Hecht's and Kann's department stores became "two modern monuments to progress." (Kann's is now part of George Mason University at Virginia Square.)

Parkington was a $14 million "miracle of planning and construction" that opened on November 3, 1951, after five years of work. Precursors of today's Forest City surveyed Arlington's spending habits, housing and traffic.

Building Ballston Mall's precursor. *Arlington County Public Library.*

They sensed "an opportunity to lure trade from congested Washington," where, every Saturday, housewives would pile into buses and streetcars to shop downtown.

The eighteen acres had to be purchased from twenty-six owners to commandeer what Parkington operating manager Milton Schlesinger said was as "close to the center of the county's population as you can get." (At least one family cemetery was destroyed, according to Eleanor Lee Templeman.)

Most revolutionary was the five levels that made this the world's largest parking building, with room for two thousand cars. Customers paid five cents for the first three hours and a dime thereafter. Their reward was convenient access to six hundred thousand square feet of space hosting 159 "departments," including McCrory's variety, Walgreens and HUB Furniture.

The anchor, of course, was the Hecht Company, with five shopping levels and an escalator. It is now Macy's. The store cost $6.5 million to build and was the East Coast's largest department store. A vintage photo shows

it taking shape through the energies of Prescott Construction Company, a wood-frame house stubbornly standing on the corner of Wilson and Glebe.

Many of us associate Parkington with the massive letter messages on a huge north-facing façade ("Drive Carefully—School's Out" or "Buy Easter Seals"). "If there is a message the Hecht Co. wishes to get across to the people, it can be displayed in letters behind the façade," said New York architect Robert Allan Jacobs. "The theory was not for display of merchandise but display of color and light. Overnight, the color of the façade can be changed by painting or hanging colored paper on the cinder block wall, which is two and a half feet behind the glass skin."

Parkington will produce "a surprising change in America's fastest growing county," the *Post* wrote. That's what the new public-private partnership hopes to do for Ballston Mall.

RIFLES ON CAMPUS

The gun dealer NOVA Armory, after an aborted lease in Cherrydale in 2015, opened a weapons outlet on North Pershing Drive in Lyon Park.

The owner offered free T-shirts to its first one hundred visitors on March 26, 2016, a kind of shot across the bow, so to speak, at citizens and legislators who've organized to protest the business.

It was a clash, of course, between Second Amendment enthusiasts and Arlington's progressives. Both camps agreed, however, that there's no legal way to block the lease, absent a landlord's change of heart.

More than thirty-six hundred people signed a protest petition at Change. org. "In an era of ever-increasing gun violence," it read, "it is unconscionable to locate a gun shop anywhere in the vicinity of schools, both private and public, with young children in close proximity."

How Arlington and the nation have changed. Before the 1999 massacre at Columbine High School, before the National Rifle Association transformed itself from a gun-safety sportsman's group to an intimidating lobby, before Arlington became less working-class, guns were routinely visible, in schools and shopping strips. From 1961 until 1999, Arlington's public high schools had rifle teams whose members carried weapons to school and practiced on campus ranges. Jim Allen, a founding teacher at Yorktown and later its athletic director, recalls that when the school opened in 1961, rifle coach Bill Beals commented, "Who ever heard of a high school rifle team?"

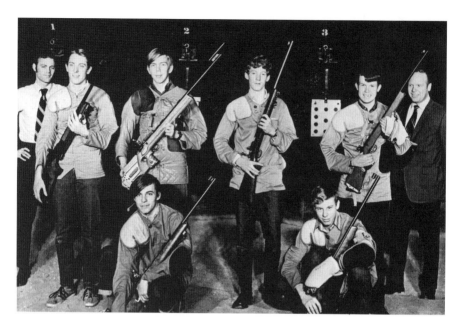

The Yorktown rifle team in the school basement. *Yorktown Grenadier.*

Allen and fellow biology teacher Clarence Seldomridge (who also coached rifle) allowed students to store .22-caliber rifles in their classroom closet because it was right up a stairwell from the range. "No one thought anything of it," he said.

The 1991 Yorktown yearbook—one of many showing the rifle team kneeling with weapons and padded coats—described that range as "deep beneath the Yorktown cafeteria." Safety protocol was strictly followed, Allen said, though one time a rifle "kicked up" and put a bullet through a water pipe. It required a police and fire fighter response, but nothing more.

One Yorktown student who loved the team was Ron Anglin (class of '66). When he was around ten years old, Anglin's father bought him a .22-caliber rifle at Sports Fair in Cherrydale. The boy walked with his weapon to lessons at the Washington-Lee High School rifle range "underneath the bleachers."

Once Anglin moved to Yorktown, it was Coach Beals who arranged for him an apprenticeship at Davis Gun Shop (7213 Lee Highway in Falls Church). Anglin would work for owner Fred Davis on and off for ten years, including while attending college. "There were some robberies, but a gun shop is no different from a jewelry store or a bank, which get robbed," Anglin told me. "It would not bother me to have a gun shop in the neighborhood."

After Columbine, the Arlington School Board voted to end campus rifle practice. The Virginia code, schools spokeswoman Linda Erdos reports, prohibits weapons on school property.

All three high schools today offer rifle teams, however, and at least a half dozen Arlington rifle students have recently gone on to compete at college level. The typically ten-member squads practice off-site using air rifles. Yorktowners travel to a range at a VFW post and Masonic lodge. Their female coach, Traci Yates, is an NRA-appointed rifle coach and NRA-certified rifle instructor.

In the community, the dispute goes on.

ARLINGTON ON POSTAGE STAMPS

Attention, collectors! I'm assembling a fresh slice of Arlington history—as told through postage stamps.

Our county boasts many assets worthy of commemoration on a stamp—the Custis-Lee Mansion, the Iwo Jima and Air Force memorials, the Tomb of the Unknown Soldier and the Pentagon. But I was surprised to learn that none of those has been the subject of an official U.S. stamp.

The true story of what gets commemorated and first-day-issued in Arlington is complicated—but unique.

Caution: I am not a qualified philatelist. As a boy, I amassed a stamp collection sufficient to stock a roadside stand that sold to a few gullible neighborhood kids. The remains of that album and book of first-day covers sit neglected in my basement.

For this history challenge I relied on Richard Rhoads, a true philatelist who buys newly issued stamps and first-day-of-issue envelopes with Arlington cancellations. From his home office lined with Scott's stamp catalogues and *Linn's Stamp News*, Rhoads told me that Arlington, being close to Washington, should be an ideal site for occasional U.S. Postal Service new issues and ceremonies. "But officials often don't want to come over the bridge," he said.

"It's usually easy to figure out why they pick a particular city or state," he said, giving the example of a Valentine's Day stamp from Valentines, Virginia.

The first U.S. stamp to feature an Arlington scene came out in 1922, Rhoads confirmed. It's a lavender fifty-cent stamp showing the Arlington Cemetery amphitheater. (Lo and behold, I found a copy in my boyhood

Commemorating the amphitheater at Arlington Cemetery in 1922. *U.S. Postal Service.*

album.) Another Arlington Cemetery scene to be commemorated was the 1964 issue showing the eternal flame at President Kennedy's grave site.

The first time the postal service issued a first-day stamp in Arlington was for the August 12, 1960 release of a seven-cent airmail stamp showing a red jet plane.

In 1970, a ceremony was held at Fort Myer to release a postal card showing a weather vane commemorating the centennial of the National Weather Service, which actually got its start at Fort Myer.

Rhoads showed me an August 15, 1981 envelope released in Arlington exhorting Americans to "Remember the Blinded Veteran." In the mid-1980s, Arlington was home to the release of two in a first-class stamp series of transportation themes, one an 1880s omnibus, the other a school bus. In 1981, a thirty-five-center honored onetime Arlington resident Charles Drew, the famous African American physician who pioneered research into blood storage for transfusions.

In the late 1980s and early '90s, Arlington provided the first cancellation for a nature series that included an owl and a grosbeak bird. We were also the site for the release of stamps showing a bobcat and a fishing boat.

On February 11, 1995, postal service bigwigs attended the dedication of the refurbished Preston King Station post office in Westover. (Rhoads owns a 1932 first-day cover addressed to King, who died in World War II.)

In 2014, Arlington was the site of one in a three-part series of commemorative stamps honoring Medal of Honor winners. The ceremony for the Korean War version was at the aforementioned Arlington Cemetery amphitheater.

One Arlington historical event that went unrecognized by the U.S. Post Office was marked by Rhoads. The 100th anniversary of the first airplane fatality—Lieutenant Thomas Selfridge, flying with Orville Wright—came in 2008. Rhoads designed his own envelope and arranged for the Fort Myer post office to give its Arlington cancellation. That's a love for both stamp collecting and for Arlington heritage.

ONE FOR THE LITTLE LEAGUE RECORD BOOKS

Arlington Little League's all-star squad in July 2015 for the first time claimed a regional district championship. (They whipped Alexandria!)

After mentally congratulating them, I found, via the son of a longtime coach, a yellowing set of lovingly typed statistics of my own generation's Junior Major Baseball League, from 1957 to 1971. They came courtesy of the old Arlington County Department of Recreation and Parks.

The buff-colored, legal-sized sheets, probably typed on some long-tossed Smith-Corona, were reproduced, in the later years, in purple mimeograph. My study of them resurrected fond memories of countless trips in parents' cars to Barcroft Park. I reconnected with some now-defunct Arlington businesses and documented early athletic feats of some future famous personages.

The first thing I noticed was the roster of long-vanished team sponsors: Vet Vans, Martz Insurance, Newlons Transfer (where I worked summers), Tops Drive-In, Old Dominion Bank, Arlington Trust (one year, it had eleven players named Mike), M.T. Broyhill homebuilders, Stewart Buick, Barcroft Cleaners, Cherner Ford, McQuinn's Sporting Goods, the Red Shield Club (a Salvation Army offshoot), Kenyon-Peck Chevrolet, Better Homes Realty and Barr Realty.

Some organizations still exist but sponsor less frequently: men's lodges such as Host Lions, Civitan, Jaycees, Moose Lodge, Knights of Columbus, along with the YMCA and since-relocated Arlington Motors. Later sponsors included St. Thomas Moore Cathedral, Wayne Construction, State Loan, Clarendon Trust and First & Citizens Bank.

The generosity of those entities provided the colorful uniforms worn by kids whose faces I can picture fifty years later.

The stat sheets begin with standings of the "National" and "American" Arlington divisions. Unlike today's league's team rankings, they provide the "batting order" of top-hitting league players, followed by each team's lineup. You get each player's at-bats, runs, hits, doubles, triples, homers, walks, strikeouts and batting averages. A history section memorializes batting and home run leaders back to 1954.

The lists use last names only, but many were unmistakable, having been larger than life to my preteen self. I recognized classmates, teammates from other sports, siblings and sons of coaches (which might explain the coaches' original interest). I spotted league-leading stats for my old gym teachers Tom Hawkins and Tim Hill.

tomac Kiwanis 323 45 40 4 3 1 74 120 .174 4 14 81 348
d Shield Club 328 52 57 5 5
cQuinns

HISTORY

	AB	H	2B	3B	HR	BA	TEAMS	GAMES	LEADING BATTERS	LEAD
1953	5,232	1,341	230	23	67	.258	12	130	Bowling	.511 Talb
54	5,319	1,382	254	45	60	.260	14	130	Hawkins	.618 Bae
55	6,744	1,692	263	57	79	.251	16	167	McGraw	.617 Ba
56	7,241	1,888	257	68	36	.261	16	175	Golden	.533 Sc
57	6,014	1,525	234	63	30	.254	18	150	Hill/Till	.581 H
58	7,684	2,013	311	71	72	.262	18	193	Gibbs	.582 C
59	7,445	1,948	347	81	62	.262	20	182	Cloer	.571
60	7,435	1,936	319	93	54	.260	20	186	Tugwell	.489
61	7,430	1,759	309	84	35	.237	20	191	Gibb	.464
62	7,251	1,842	294	103	47	.255	20	191	Salthouse	.581
63	7,547	1,850	270	86	54	.245	20	194	Miller	.577
64	7,479	1,801	260	71	72	.241	20	194	Stein	.591
65	7,018	1,720	245	92	21	.245	20	184	Jordan	.512

LEADING BATTERS

SB .395 Br Lc

Proof of Little League record-setters. *Charlie Clark.*

A kid named Kirby is surely Clay Kirby, who went pro and pitched for the San Diego Padres and Cincinnati Reds. In 1960, he hit .313 for Arlington's own Stewart Buick. Kirby's boyhood next-door neighbor was John "Jay" Franklin (my teammate on a twelve-year-olds all-star team), who was drafted out of high school in 1971 to pitch in three games for the San Diego Padres. In 1965, he batted .444 for the Arlington Kiwanis.

Tyler Mathisen, now on television as managing editor of CNBC Business News, in 1968 batted .172 for Knights of Columbus. Bobby Tramonte, owner of the Italian Store, in 1965 batted .212 for State Loan. (Hey, guys, you were warned about your "permanent record.") Myself? In 1965, I hit .290 for Evening Optimist.

Early promise was shown by names of those who later starred in high school (Yelverton, Chaconas, Kirchner, Lichty, Slade, Benevento). My friend Bill Carter, the Yorktown High School three-sport star in 1969, as a twelve-year-old in 1963 batted .400 for Optimist Club.

Many of these statistics were compiled by a team mom, Mrs. DeNelson Ward. The later ones were signed as written and typed by "LGH/ad." Whoever bore those initials, thanks for the memories!

TEARING DOWN HISTORY

The teardown specialists in 2016 began targeting old homes on historic Minor's Hill.

As the highest point in Arlington, this prominence at the Fairfax line figured in the War of 1812 (Dolley Madison allegedly stayed there while escaping the British) and as a Civil War observation post owned by the secessionist Minor family and coveted by both sides.

In June 2016, preservationists sounded alarms that a "Civil War–era Confederate home" was to be demolished, and county officials scrambled to respond. The white two-story house on Minor's Hill's western slope at 6808 North Thirty-First Street was sold by the Flynn family to a builder in March for $975,000, and a demolition permit was filed.

To call it a Civil War home is a stretch. The history, as compiled by the Virginia Department of Historic Resources, notes that the house sits on land said to have been the site of a Confederate headquarters and owned by contractor James Phillips. The dating of the threatened house is unclear; it contains early twentieth-century additions. It was "not a rendition of a high style," the historians wrote.

Still, it is vintage and unusual. Among those who came to its defense was Joan Lawrence, speaking as a private citizen through her expertise as chairman of the Historical Affairs and Landmark Review Board. "At a minimum, action on the demolition request should be delayed until additional information on its history can be obtained," she wrote the county manager. "It is possible to designate the house as a local historic district under an expedited process…if a compromise to preserve it cannot be worked out."

Also weighing in was Eric Dobson, the force behind Preservation Arlington. He told me: "This is a great example of an old house with an interesting history. But we don't know everything. Unfortunately this is a monetized situation where the family needs to get out—the developer made an investment."

The county replied as "bearer of bad news." The permit for the "by right" new owner means "Arlington County has no legal authority to delay or stop the demolition."

I contacted the custom builder, Matt Rzepkowski of MR Project Management, who said he didn't focus on the history of the property, brought to him by an investment group. He has designed two modern replacement homes but hasn't yet submitted plans. Rzepkowski is also set

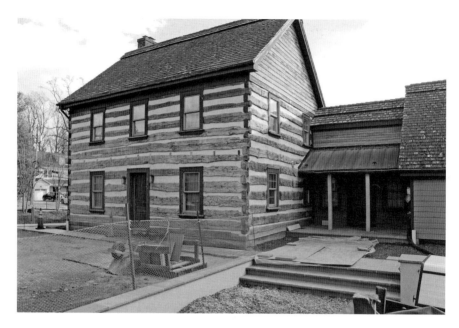

Two-century-old cabin chinking on a modern home. *Samantha Hunter.*

to build three homes to replace an eighteenth-century home on the eastern flank of Minor's Hill, two blocks into McLean, at Virginia and North Nottingham Streets. Realtor Tom Francis told me that the sellers made plans for subdividing that property.

Simultaneously on the market (and vulnerable as a teardown) is the eighteenth-century log home attached to a modern structure at 3610 North Powhatan, half in Arlington, half in Fairfax. The owner, antiques dealer Charline Keith, seeks $2 million for the hidden home on one acre showcasing the 1770 log house she and her late husband trucked down from Chambersburg, Pennsylvania. (They transported a similar old log home from near Gettysburg; it now stands at Old Dominion Drive and Williamsburg Boulevard.)

Keith showed me the home's "chinking" (mortar and wire) between ancient logs that show carpenter's strokes, downstairs from the bedroom with a hot tub. Keith has battled neighbors over preservation and subdividing rights.

Preservationists want more publicity for old homes and closer study before the wrecking ball does its work. Or, as Keith asks, "Why not move it?"

MAPWORTHY ARLINGTON

My high school buddy Dave McGarry worked for the Arlington County Planning Office back in the 1970s. With his bosses' permission, he copied five blueprint-style engineering maps of our sainted twenty-six square miles, covering 1935 to 1975.

He bequeathed them to me in his recent downsizing move. As befits my role as "Our Nerd in Arlington," I pored over them and extracted some nifty forgotten facts about our hometown.

The April 1935 map was the first map executed after Arlington reshuffled its street names, during which Memorial Drive/Garrison Street became Washington Boulevard and North Pennyman Street became Madison Street.

It shows lesser-known waterways: Roaches Run near the modern-day Fourteenth Street Bridge and the Three Sisters Islands in "Little River" off Roosevelt Island, which until the late 1930s was Analostan. (Three Sisters was the name for the 1960s proposed Spout Run commuter bridge that never got built.)

Some street names changed in 1935, but not all. *Charlie Clark.*

The map shows how few homes then occupied the woods along the Potomac off Military Road, where today are nestled the subdivisions of Bellevue Forest and Rivercrest.

I spotted vanished streets, such as "College Lane" near the Buckingham apartments. My own Roosevelt Street in the 1930s stopped east of Lee Highway, and Sycamore Street was truncated around Little Falls Road. A shorter Old Dominion Drive stops at Lee Highway before Stratford Junior High existed.

Most noticeable were the long-shuttered schools. Nellie Custis Elementary (near today's Crystal City); James Monroe (on Key Boulevard); Henry Clay (Seventh and Highland in Clarendon); Hume (now the Arlington Historical Society) and Cherrydale. Three were labeled "colored"—Hoffman-Boston High School (now an elementary school), John Langston (now a community center) and Kemper (renamed Drew in 1952). Several names were attached to buildings still standing but repurposed: Stonewall Jackson (now Arlington Traditional), Woodmont and Lee schools (now community centers), Maury (an arts center) and Saegmuller (the Madison senior center).

On the 1942 map, you find the then-new Pentagon, along with a stream near Barcroft Park called Doctor's Branch. Today's Fourteenth Street Bridge is labeled the "Highway Bridge," and you see elementary schools Reed and Barrett.

On the 1952 map, I noticed an Old Dominion School (the main building of today's Marymount University) next door to John Marshall Elementary School at Twenty-Sixth Street and Glebe Road, now the site of newer Marymount buildings. (I knew it as the Marshall Annex baseball field in the 1960s, before the Yorktown Boulevard underpass was built.) At South Glebe and modern I-395 stood Dolly Madison Junior High. On North Underwood one sees Charles Stewart Elementary School (now a soccer field). Yorktown High School was an elementary school. I spied a now-vanished Frazier Road near Arlandria. (The map shows Arlington Boulevard as Lee Boulevard, though that change was made soon after.)

The 1961 map (with projections to 1966) has Sycamore Street continuing across Lee Highway and Washington Boulevard past today's East Falls Church Metro. The drawing, done before I-66 pierced the county, shows routes of Fairfax Drive and Bluemont Drive that are longer than today's.

By 1975, the engineers' map was multicolored. For the first time it showed Metro stops. I-396 was still called Henry G. Shirley Memorial Highway.

Viewed together, the maps quietly dramatize how the sands of time have shifted in our cozy twenty-six square miles. I gave them to Arlington Central Library's Center for Local History.

THE RESPONSE TO 9/11

Arlington was one of the three American communities to solemnly mark the September 2014 anniversary of the 9/11 terrorist attacks with personal experience.

Arlington County fire chief James Schwartz recounted his role as head of unified command at the smoking Pentagon on that harrowing day. His audience from the Arlington Historical Society felt proud that our county is viewed around the nation as a model for first responders.

Fresh from a Capitol Hill ceremony that bestowed Congressional Gold Medals on the 9/11 memorials in Arlington, New York City and Shanksville, Pennsylvania, Schwartz made it clear how familiar his team has been with firefighting at the Pentagon.

He showed a July 2, 1959 photo of trucks battling a blaze there stoked by air force computer tape that for years constituted the country's largest building loss to fire. "In my career, we've had more multi-alarm fires at the Pentagon than anywhere, including one three weeks before 9/11 and another two weeks later," said Schwartz, who joined Arlington's force in 1984 and has been chief since 2004. Ironically, the 9/11 plane struck sixty years to the day that ground was broken to build the Pentagon.

As the weaponized 757 jet that had taken off from Dulles flew shockingly low and clipped light poles, it was watched by drivers on Columbia Pike and Washington Boulevard, he recalled. The deepest personal impact was felt by rescue vehicles from Fort Myer that were on the site for other reasons, Schwartz said, but the first responder was Truck 105 from Crystal City, which was there in two minutes.

He arrived within ten minutes to confront carnage and flames from six thousand gallons of jet fuel and white-hot rivets that bored through to the building's C Ring. "Fortunately, much of the building was unoccupied due to a renovation," he said. "If the full 25,000 had been there, I'm sure casualties would have been worse than at the World Trade Center."

Ad hoc Pentagon reconstruction over the decades made the building more of a death trap, with poorly designed walls and an often-repaved tunnel road whose clearance could no longer accommodate the fire team's vehicles until their roofs were cut.

But the result "was a rare incidence of unified command working," said Schwartz, who led with an FBI counterpart. Coordinating with Arlington's Emergency Operations Center, his team worked twelve-hour shifts (he worked thirty-six hours straight).

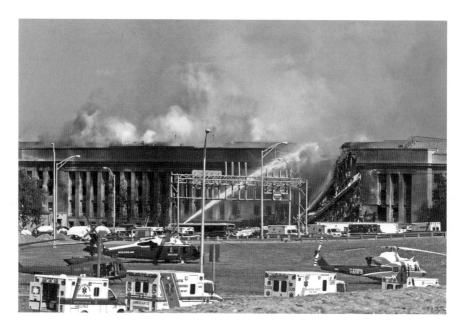

Arlington emergency responders active at the Pentagon on 9/11. *Chuck Kennedy, Library of Congress.*

They evacuated personnel, summoned mutual and automatic aid from neighboring jurisdictions, assigned police to gather evidence (including employees' cars, which had to remain on the site), briefed the press, set up a high-volume food station and navigated the politically fraught intergovernmental permissions process.

Arlington, Schwartz noted, was better rehearsed for such eventualities than most communities, owing to lessons from several past events, including the 1973 collapse of the Skyline Towers construction at Bailey's Crossroads, the 1982 Air Florida crash on the Fourteenth Street Bridge and the 1995 bombing of the federal building in Oklahoma City and sarin gas attacks in the Tokyo subway.

One of Schwarz's photos shows clearly marked debris from the American Airlines plane that should end all conspiracy theories about what caused the Pentagon fire. "On the Internet, you can find calls for my arrest, blaming me and my FBI colleague for 184 deaths," he said.

The careful gathering of evidence—down to finding the terrorists' drivers' licenses—"explained how the hijacking occurred."

Sparkling Personalities

A Pillar of the Ball Family

If there is a first family of Arlington, it would be the Balls. These landowners going back to the Revolutionary War lent their name to our crossroads neighborhood of Ballston.

In August 2016, I got the chance to pose questions to fifth-generation descendant Barbara Ball Savage. She's the daughter of the illustrious Frank Ball (1885–1966), the early twentieth-century attorney, state senator and historian who raised Barbara and her three siblings in our county's iconic Glebe House. Now those are deep-dyed Arlingtonians.

When Barbara was born on Election Day 1927 (to a mother from the landed Shreve family), her father, Frank, was a progressive candidate for state senate working against the powerful Byrd machine. (Ironically, he became Senate seatmates with Harry Flood Byrd.) Frank would later push to end the poll tax. His earlier years as commonwealth's attorney meant he prosecuted hard criminals at a time when Rosslyn was so dangerous, Virginia farmers bringing produce to D.C. markets were terrified to pass through, Barbara said. The Ku Klux Klan went after Frank. He became the first president of the Arlington Bar Association, joined the Virginia State Welfare Board and helped launch a Depression-era Arlington newspaper, the *Chronicle*.

Like his forebears, Frank Ball Sr. was a lifelong pillar of Mount Olivet Methodist Church. It's the county's oldest, founded before the Civil War by

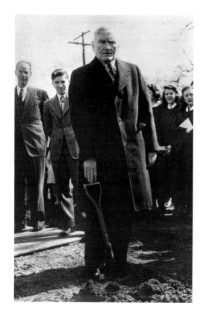

State senator and law giant Frank Ball. *Ball family.*

an assembly of Arlington gentry—Ball, Marcey, Wunder, Minor, Birch, Payne and Veitch.

In his 1965 church history, Ball tells of finding bones in the cemetery that he suspected were those of Union soldiers. He found it odd that none of the tombstones were so identified even though Federal troops "destroyed the pews" to set up a hospital after the battles of Bull Run.

Ball honors Sue Landon Vaughn, the founder of Memorial Day, who rests at Mount Olivet. Ball family members continue to place flowers on her grave. His other nifty Arlington memories include sightings of President Woodrow Wilson traveling by car to the Washington Golf and Country Club. "Many times I have seen him stop along the road and ask pedestrians to climb in and have a ride," Ball wrote.

In his preface, Ball gives his address as The Glebe, Arlington, Virginia. That two-century-old octagonal building on North Seventeenth Street (featured on the covers of phone books in my youth) bequeathed Barbara Ball fond memories of "seven outside doors that were never locked." In 1956, it hosted the first meeting of the Arlington Historical Society.

Barbara Ball attended Thomas Nelson Page School (now Science Focus) and graduated from Washington-Lee High School in 1946. "The whole county was so proud of W-L; it was the center of so much when Arlington was rural," she said. She met her future husband, an FBI agent, at George Washington University and later sold gifts at National Orthopaedic Hospital.

Barbara gave me a tattered copy of the *Arlington Daily* from January 5, 1950. The front page carried a photo of Frank Ball Sr. presiding over a luncheon feting Jim Thorpe, in town to receive the Washington Touchdown Club's "Greatest World Athlete Award."

Ball's ancestral graves can be visited at Washington Boulevard and Kirkwood Road. Other Ball tombstones from the eighteenth century line the yard of Central United Methodist Church on Fairfax Drive.

With only daughters in the later generations, Barbara confirmed, the Ball name for direct descendants has effectively ended.

PATTON'S ARLINGTON YEARS

Count among Arlington's notable residents of yesteryear "Old Blood and Guts."

General George S. Patton Jr. (1885–1945), famous for leadership in two world wars, ivory-handled pistols and slapping scared soldiers in Sicily, was colorfully portrayed by George C. Scott in the 1970 movie *Patton*.

Stateside, Patton's life unfolded at homes in and around Fort Myer, the sites of which are traceable.

The respected but resented officer was stationed four times in the Washington area, I was told by Kim Holien, retired as historian at Joint Base Myer–Henderson Hall. Patton and his wife, Bea, "were very socially oriented, because they were upper-crust and because that was a way to keep his name and face in front of the powers that be in the slow promotion system between the wars."

Patton was first stationed in Arlington in 1911, when the ace horseman joined the Fifteenth Cavalry Regiment at Fort Myer. He was already mingling with superior officers, lawmakers and cabinet members, wrote Patton biographer Stanley Hirshon. In the summer of 1912, the twenty-six-year-old VMI and West Point graduate traveled to Stockholm to compete in the Olympic pentathlon.

Patton developed "the last official saber for the Army," Holien said.

Following action in World War I in France, he returned to Fort Myer as a major and squadron commander and helped prepare the 1921 dedication of the Tomb of the Unknown Soldier.

After finishing at the Army War College in June 1932, Patton and his wife rented a two-year-old house in Rosslyn. It boasted "a gas stove and furnace, five bedrooms, four rooms for servants, two guest rooms, and a flower garden," Hirshon reports.

One letter from Patton's wife, copied to me by the Huntington Library in California, contained, rather than a street address, "RFD #1 Roslyn or Ft. Myer if you trust Georgie to bring it home."

From this house, Patton learned of the "bonus marchers" near the Capitol—seventeen thousand impoverished World War I vets demanding back pay. Patton saw the marchers as "revolutionists" and "a mob" and helped put them down (one protester had been a soldier who once saved Patton's life).

In 1935, the Pattons bought land from Fort Myer and built a home at North Twelfth and Nash Streets. It was later described as an elegant two-

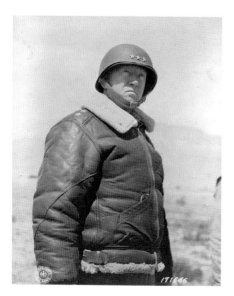

General George Patton lived in a manse near Fort Myer. *Library of Congress.*

story fieldstone, with dark-wood paneling, crown molding, hardwood floors and a spacious kitchen. The Pattons lived there six years; after Pearl Harbor, it was sold to the Devers family for their fledgling Congressional School (originally a farm on Carlin Springs Road). In 1960, a fire forced Congressional to move to today's location on Sleepy Hollow Road. The Patton home was razed in 1963. George Patton had been promoted to commander at Fort Myer in 1938. He was one of the last to live in Quarters 8 on Grant Avenue, Holien said, before General George Marshall assembled senior officers at other nearby quarters for security and communication.

That was after Patton, in 1935, designed the Old Post Chapel "top to bottom, doing extensive research on a tight budget," Holien said. A chapel plaque mounted in 1955, however, credits Patton's former boss, General Kenyon Joyce. That, historian Holien assured me, was due to the famous falling out between Patton and Dwight Eisenhower in Europe before Patton's death in a car accident. First Lady Mamie Eisenhower and the Joyces dedicated the plaque—with Patton's role nearly forgotten.

BUSINESS EDITOR AUSTIN KIPLINGER

In the world of consumer finance forecasts, Austin Kiplinger is a walking brand name. What is less known is that the ninety-seven-year-old editor emeritus of Kiplinger Washington Editors spent a very happy childhood in our own Arlington.

"I have lots of memories from 1924, very vivid years aged six to fourteen," he told me in a crisp phone interview in August 2015. "We lived in Lee Heights, up the hill from Rosslyn alongside the W&OD electric railway near what today is Old Dominion Drive."

Kiplinger, the son of the company's founder, said his father and grandfather (a retired carriage maker from Ohio) bought three lots from longtime Arlington landowner Ruby Lee Minor. They built houses on what then was Spring Drive (named for a local water source), today's Vermont Street. Teddy Roosevelt and White House physician Admiral Preston Rixey "took their weekend drives there," said Kiplinger, a major collector of Washingtoniana and benefactor of District of Columbia history.

"But our upscale subdivision never caught on—the streets were not paved," he said. Still, "Mrs. Minor built a tennis court between Lorcom Lane and Vermont Street, one of the great attractions of the neighborhood, though none of us played tennis."

As a boy in the 1920s, Kiplinger delivered the *Evening Star*. "It cost a nickel, and I got two cents a paper," he recollected. "I really worked for that because of the great distances between houses—if I were in a city, I could throw a paper on every front porch."

His pal Bob Thomas had a "really big house on Lorcom Lane, with a porch and chicken coop in the back. We converted it into a sports club and held boxing matches," he said. Kiplinger also recalls playing in Donaldson Run and hiking down to the Potomac cliffs—"I knew every inch of those woods," he boasts. In the nearby "Marceytown" community was Marcey's grocery, which offered fresh country meats and produce from the D.C. central market every Thursday.

Famed business editor Austin Kiplinger was nostalgic for old Arlington. *Kiplinger family.*

The future business editor went to elementary school at Carnes, a two-room structure for four grades built in the 1890s near a railroad track at modern-day Glebe Road and North Twenty-Sixth Street. He also attended John Marshall. "Dr. Sutton, our family doctor, had a house at the end of the street," Kiplinger remembered. There was also Puglisi's grocery store, "where I could buy a licorice stick for one penny, before inflation."

In the early 1930s, Kiplinger attended Washington-Lee secondary school, led by Principal Vanderslice, whom he imagines few recall. One teacher he has never forgotten was Miss Allen, the Latin instructor, for whom he worked on a

newsletter written in that dead language. (Kiplinger can still spell "Ab ova usque ad mala," which translates roughly as "from soup to nuts.") Miss Allen "was an iconic figure in W-L history," Kiplinger said. She encouraged him to edit the publication his sophomore and junior years, promising he would earn "good marks."

When senior year rolled around, the Kiplinger family publishing company was thriving, so the prodigy Austin was transferred downtown to Western High School. "My teachers in civics expected me to always know the answer, which was very disconcerting." He went off to Cornell University and led the career expected in his prominent family.

"Yes, I still visit Arlington," he told me. Plenty of the modern Kiplinger staff are Arlingtonians. (On November 20, 2015, two months after this profile was published, Kiplinger died.)

WESTOVER POST OFFICE NAMESAKE

Preston King is, to many locals, simply the namesake of the Westover Post Office.

But for two Arlingtonians, the neighborhood hero killed in World War II remains a vivid presence—despite the fact that they are too young to have ever met him. Both shared with me fresh details.

Chip Beck, retired from the CIA and Naval Criminal Investigative Service, is a skilled combat artist. That's his pastel portrait of Preston King you see while in line at the post office. Beck also wrote the displayed King bio, a labor of love far beyond what the postmaster expected when he commissioned the painting of King in time for the 1995 dedication of the remodeled post office.

Beck described his research to fill in lost details of King's life, using friends' recollections, a yearbook, photos and news clips.

King, the son of a sports business manager, was known to intimates as "P.K.," a Westover boy (North Eleventh Street) who graduated from Western High School downtown in 1935. He worked in construction and real estate before Pearl Harbor and then enlisted in the Army Air Corps flight school. After qualifying as an officer and undergoing pilot training in Florida, he was sent to Panama with the Thirty-Seventh Fighter Group, Thirtieth Fighter Squadron to fly P-38 Lightnings.

The second lieutenant's letters home were vague on location and assignment due to wartime censorship. But Beck, whose work in the 1990s

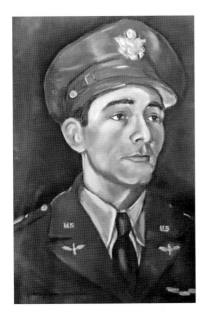

Post office namesake Preston King painting. *Chip Beck.*

took him to Panama annually, visited the archives at Howard Air Force Base and found records of King's assignments. On June 19, 1943, King was flying a reconnaissance mission over an unspecified territory when he was forced to bail out of the cockpit. Due to the poor design of early P-38 fighters, when he rolled over the wing, he was decapitated by the tail section.

The body was brought to Gorgas Hospital (and later buried at Arlington Cemetery), Beck learned while visiting the Panama sites where King and mates would have spent leisure hours. "I felt like I was walking in his footsteps," he said.

My friend Karla Sorensen, who worked in her family construction business, grew up knowing that her parents were P.K.'s inseparable friends. Lester and Margaret "Dodie" Sorensen roomed with him before their war service, and the two men enlisted. "One of the nicest thoughtful gentlemen who ever walked the earth," Karla's mother said. The family recalls a high school episode in which a girl knocked P.K. down; he resolved, "If a girl hits you, don't hit back."

Karla, whose family visited P.K.'s mother throughout her childhood, grew up with the hero's photo (on which Beck based his portrait) on the wall. She showed me King's wartime letters, one consoling her father after he was reassigned from pilot to lead bombardier. "Maybe you are lucky," King wrote. Sorensen's eventual role would bring "excitement, going places, a swell bunch of fellows and last but not least, the flight pay," P.K. promised.

King described life in Panama as "jungles, mountains, scorpions, head-hunters, snakes....Never a dull moment." Deeper in the jungle, he wrote wryly of "some very fine upstanding head-hunters....They are quite the fellows when you get to know them. But...I was always bashful."

P.K. also wrote that he and his buddies "drank two joints clean out of Scotch." He told Lester Sorensen to watch the newsreels: "P.K. might be in one."

W-L ATHLETE IN WORLD WAR II

Arlington Cemetery conducted a special ceremony on June 13, 2016, that weaved together a tragedy from World War II and achievers in current-day Arlington youth sports.

The Merrill Hoover Award, which is given annually to a top female high school athlete by the Better Sports Club of Arlington, is named for a sports star from Washington-Lee High School's class of 1941 who died fighting the war.

Merrill Hoover's modern brethren in the fraternal Order of DeMolay arranged with cemetery authorities for erection of a headstone with full military honors by the U.S. Coast Guard, even though Hoover's body was never recovered.

Merrill Walter Hoover, born in 1923 and raised at 4323 North Pershing Drive, was a football and track star at W-L. That's according to clippings compiled by Tom Varner, a Richmond-based DeMolay member who bird-dogged the Hoover story as part of a quest "to know what kind of men DeMolay made," he told me.

"Hoover was considered the best athlete W-L produced in the first half of the twentieth century," Varner said. He was a record-setting placekicker on the football team, shot-put medalist on the track squad and winner of a football scholarship to Clemson University. He was chunky, his classmate Rosemary Trone Lewis recalls, his photo revealing a sober, square-jawed young man with parted dark hair.

His stay in faraway South Carolina, however, didn't last long. He was enrolled back home at American University to be near his mother, a widowed piano teacher, when Pearl Harbor was attacked. He also became a past master councilor in DeMolay's George Washington chapter in Arlington.

Like thousands whose educations the war interrupted, Hoover enlisted. As a seaman second class, he was on a two-masted schooner called the *Blue Water* patrolling for German U-boats off the coast of Virginia with the Coast Guard's Corsair Fleet (nicknamed "Hooligan Navy").

On April 10, 1943, amid nighttime fog and ships cruising without lights to avoid detection, the vessel collided with a Dutch freighter. Hoover raced to warn his shipmates sleeping in the forepeak before he was, apparently, washed overboard, according to official Coast Guard accounting.

In letters to his family, the shipmates, all of whom survived, testified that Hoover would have known that his action meant certain death. "Arlington boy, football star, lost at sea," reported the *Washington Post* on

Merrill Hoover (*back row, center*) in a prewar family photograph. *Hoover family.*

May 27, 1943. Hoover received a posthumous accolade from President Franklin Roosevelt.

For decades, Hoover's devastated family, according to Varner, "had had no closure and had done nothing because the mother kept thinking her son would walk through the door one day."

In 1946, W-L memorialized all of its alumni killed in the war and created the Merrill Hoover athletic trophy for the outstanding senior athlete. When the Better Sports Club of Arlington was formed in 1957, it took over the award, I'm told by president Rick Schumann, who attended the June 13 event.

Varner, a chemical engineer, said he felt "chills going down my spine" when he was finally able to link up the Coast Guard historians, Hoover's niece (she lives in Arlington) and the cemetery authorities for the committal service in a section of the cemetery for those missing in action.

He is researching other DeMolay heroes and plans to nominate Merrill Hoover for the fraternal order's own medal and hall of fame. A local hero gets his due.

NINE DECADES IN ARLINGTON

The honor of being the most senior lifelong Arlingtonian could easily be given to John Moore.

The ninety-six-year-old told me in February 2015 that he lived and worked for nine decades within one square mile of Arlington.

Moore was born at his parents' home in Ballston on June 29, 1918, when Arlington was Alexandria County. He was named for his godfather, who owned Ballston Drug Store. He attended the original Thomas Nelson Page School when it was at Wilson Boulevard and Quincy Street, then Cherry Valley Road.

Moore entered Washington-Lee at age twelve in 1930, as the crowded building was expanding. He recalls a day when "several of us in a lab were standing by windows making noise, and chemistry teacher Mr. Christie threw a piece of chalk, saying, 'I can't hear myself think!'"

He soon became a cadet, wearing a uniform and carrying a sabre. (Moore stopped attending W-L reunions in the 1980s but remains in touch with one female classmate in Texas.)

Moore's first job was as a caddy at Washington Golf and Country Club. Though the going rate was seventy-five cents per bag, the boys routinely told golfers it was one dollar. "On a good day we'd go home with five dollars."

Moore's boyhood included clerking at Sanitary Grocery (precursor of Safeway) at Fairfax Drive and North Stuart Street. Potatoes arrived in one-hundred-pound sacks, and it was his job to transfer them into five- and ten-pound bags, he said. "If a customer spent ten dollars, it took two people to carry the groceries."

After graduation in 1936, Moore pumped gas at Washington Boulevard and Glebe Road (now Japanese Auto Care), marveling at how his boss made money quickly to clear ownership. After a stint at a bottled gas company in Falls Church, Moore in April 1941 landed a career job at C&P Telephone installing phone lines in the temporary navy buildings on Constitution Avenue. He was there, sleeping under his desk, when colleagues ran in shouting that Pearl Harbor had been attacked.

Moore worked on the Pentagon construction site with "cables hanging all over the place."

Though C&P got him deferments, he yearned to enter the Army Air Corps. But when he took a test at the base in Bolling, he was declared color-blind. Fearful of being drafted into the infantry, Moore went home and memorized the color test books, eventually landing a slot training as a navy pilot in Pensacola, Florida.

Back at C&P (at Wilson Boulevard and Irving Street), he met Regina, who became his wife in 1947. They moved to Colonial Village apartments, then to Falls Church before buying his current home on Arlington's Harrison Street in 1957. The couple raised three daughters.

In 1953, Moore left C&P and opened an Esso gas station at Wilson Boulevard and Kansas Street. It became Moore's Auto Service, lasting thirty-eight years before he sold it and semi-retired. Regina (who died in 2007) kept the books so she could collect Social Security.

Moore recalls Arlington's segregated neighborhoods and long-gone bowling alleys next to C&P and Colonial Village, back when we were "more rural." He once knew all of the old street names—Garrison, Lacey and Memorial Drive, which morphed into Washington Boulevard.

Now legally blind, Moore gets help from his live-in daughter, still witnessing Arlington's passing show.

PHARMACIST TO THE PEOPLE

Lots of historic change has unfolded in Arlington's Nauck neighborhood, most of it witnessed up close over six decades by Leonard "Doc" Muse.

In January 2014, the county board honored Muse—the seven-day-a-week proprietor of the Green Valley Pharmacy since 1952—with a historic designation. In November 2014, it held a ceremony to install a marker for a new historic district, describing his workaday site as "the county's longest continuously operating African American–owned pharmacy."

Muse's shop looks out on the coming grant-funded public art project on the square of the historically black neighborhood at Shirlington Road and South Twenty-Fourth Street.

Muse, in his early nineties, is hard to get a hold of, owing to his work schedule. But when I popped in with visitors from the D.C. Historical Society, he emerged to greet us. We noticed the free bread that his pharmacy offers customers and needy passersby. "We have bread whenever a truck drops it off, from different companies," he told me recently.

Born in Del Ray Beach, Florida, Muse came to Washington in 1944 to study pharmacy at Howard University. With classmate Waverly Jones in 1952 he opened the store to serve blacks who, because of segregation, had little access to prescription drugstores such as People's (at least not through the front door). They took over the building that had been Hyman's Grocery.

"Green Valley served both black and white customers," the historic designation reads, "and it was especially popular for its dine-in food counter, where breakfast, lunch, dinner and an abundance of ice cream desserts were served. In the early days, an order of two hot dogs cost just 25 cents."

Community pharmacist for more than half a century, Doc Muse. *Charlie Clark.*

The route was not all romantic. Many blacks assumed that his products were inferior. As desegregation in Arlington eased, drug dealers drifted in. Muse told *Washington Post* reporter Patricia Sullivan that police suspected him of being in cahoots with those dealers, wiretapping his pharmacy even though Muse never hesitated to summon police. To avoid suspicions that he was selling alcohol to teens or unauthorized medicine to addicts, he stocked such products behind the counter. At one point, violence prompted him to keep a gun.

These days, Muse dons his white coat and works from 7:00 a.m. to 9:00 p.m. daily, with an hour off on Sundays, working alongside his pharmacist granddaughter. He paid little attention to the recent fanfare, which included testimony from neighbors celebrating his quiet contributions.

The ceremony unveiling the plaque drew family and customers along with community members and civic leaders, among them the head of the Arlington chapter of the NAACP, the assistant dean of today's Howard College of Pharmacy and Nauck Civic Association president Alfred Taylor Jr. "We can't forget to honor the bridge-builders," Taylor said. "This once-

neglected community is now one of our most diversified. And Doc was a role model for kids who aspire to higher education."

Nauck itself, however, doesn't stay still. In early 2016, a developer razed the George Washington Carver Homes on South Rolfe Street, the last remaining homes built for African Americans who lost out when the Pentagon went up in the early 1940s.

Muse told me he was honored by the historic designation of his shop, but, he said, "I haven't seen any difference yet. I'm waiting for Nauck's clientele to change, banking on more affluent customers, of more races."

OUR MARRYIN' SAM

If there's a Marryin' Sam in Arlington, that would be Gerald Williams.

From his basement office in a 1940s vintage small-practice law building on Courthouse Square, the eighty-something Williams performs "no appointment necessary" civil weddings that take under an hour to perform. Averaging twenty-five to thirty marriages per week, Williams figures that, since embarking on this labor of love in 1982, he has delivered the no-frills pronouncement to more than seventy-one thousand couples.

"It's a lot of fun, and makes people happy," Williams said on a Thursday in which he'd conducted five before I arrived. "It's reasonably steady and not a whole lot of work, though you do have to sit here all day."

Arlington attracts aspiring couples from all over the area who lack the patience, money or devotion for a congregation wedding. That's because Virginia differs from Maryland and the District of Columbia in that it requires no three-day waiting period and no blood tests, Williams explains. Also, D.C. offers no magistrates (Arlington has two others besides Williams), requiring instead a judge or religious celebrant.

The cost is thirty dollars for the license and fifty dollars for Williams's ceremony, collectable "after they both have said 'I do.'" The secular ceremony includes the familiar phrases "to have and to hold" and "by the authority vested in me by the Commonwealth of Virginia." He does quiz the couples briefly to gauge seriousness. But he also peppers his protocols with jokes, informing fidgeting participants that the reason he asked them to stand on a certain spot is that, should they answer questions incorrectly, a trapdoor will be activated.

Many clients "tear up" during vows, Williams said—even grooms.

Born in Mississippi and raised in Arkansas, Williams served in the marines before starting a career as an auditor for the U.S. Agriculture Department. In 1959, he was offered a raise if he would transfer to Washington. Eventually, he got the bug to go to law school, and like many in Arlington's close-knit postwar legal establishment, he went at night at George Washington University. "The all-day admissions exam cost thirty dollars, but I had missed the registration deadline," Williams recalls. Luckily, there was a makeup, and he soon was auditing by day and going to class five nights a week for three and a half years.

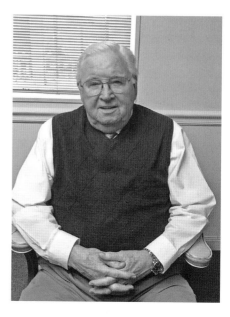

An attorney who performs dozens of weddings per week. *Gerald Williams.*

He was quickly in good company, partnering with Arlington judicial giant Harry Lee Thomas doing real estate and other specialties. (Williams continues to dabble in real estate law, but only for established clients.) In 1982, after his partners became judges, a deputy clerk mentioned a vacancy on the civil magistrate's roster.

Williams had done divorce work but found it distasteful. (A quickie divorce practice operates in his building.) Married to the same woman for fifty-plus years, he has the authority to advise clients that "it gets better every day." But his incantations haven't prevented some clients from returning to report that the marriage didn't take.

Part of Williams's job is to proofread marriage applications (now completed electronically), which avoids the hassle of a petition to correct.

In 2010, a pair of American University students arranged with Williams to film some clients taking the plunge. Their documentary is on YouTube, found under the title "Arlington Is for Lovers."

Asked whether he has performed same-sex ceremonies since they became legal in Virginia on October 6, 2014, Williams said, "Yes, but not many. Those couples seem to go to Magistrate Carla Ward."

Tracking Arnold Palmer

Golf legend Arnold Palmer had an intimate tie to Arlington, though he may not have been aware of it.

My scooplet on this topic was achieved after a friend who attends Resurrection Lutheran Church told me that Palmer was married at that sanctuary at 6201 Washington Boulevard.

That was news to me, too. A check of the local press for 1954, however, found no coverage of such nuptials, though Palmer was already on the cusp of fame, having won the U.S. Amateur. A perusal of Arnold Palmer biographies indicated that he married the former Winnie Walzer in Falls Church, Virginia.

The mystery took some effort to unlock.

Recall first that the king of the links from Latrobe, Pennsylvania, won ninety-two pro golf tournaments beginning in the mid-1950s, including the Masters four times. After "Arnie's Army" (his on-course fans) became a household phrase, Palmer in the 1960s was named "Athlete of the Decade" in an Associated Press poll.

Golf legend's name in an Arlington church wedding registry. *Resurrection Lutheran Church.*

Palmer, who died in 2016, had retired to shepherd various businesses from Orlando, Florida, and he remained big business. A three-part documentary aired on the Golf Channel in April 2014, he did commercials for medical products up until his death and his namesake beverage combining iced tea and lemonade is on grocery shelves near you.

Palmer's memoirs and biographies dramatize his "lightning struck" love at first sight for Winnie at a Labor Day 1954 tournament in Shawnee, Pennsylvania. "The quieter, prettier dark-haired girl caught my eye," he recalled of the "feisty" nineteen-year-old student in interior design. "The direction of my life changed" when Arnold sauntered over and invited her to watch him play and attend a dinner-dance. Within days, he popped the question.

Sadly, the former college sports star was at that time a paint salesman who lacked confidence that Winnie's father wanted her to marry a "golf bum." He was right. Palmer wanted to give her a proper wedding and honeymoon in London after his inevitable first pro earnings came in. Instead, just after Christmas, they eloped—to tie the knot in Falls Church, Palmer recalled.

They honeymooned at a trucker's motel in Mechanicsburg, Pennsylvania. (Arnold spent the next forty-five years, until Winnie's death in 1999, making it up to her.)

The problem with this account is evidence shared with me by Resurrection Lutheran pastor Scott Ickert. Church records in a secretary's hand "show that an Arnold Daniel Palmer, age 25, from Youngstown, Pa., and a Winifred Sarah Anne Walzer, age 21, from Coopersburg, Pa., were married at Resurrection on 20 December 1954." In Arlington.

I ran this by Jane Kovich, a spokeswoman at Arnold Palmer Enterprises in Cleveland. She assured me that Palmer's aide of four decades is certain that Palmer was married on December 20, 1954, at Falls Church Presbyterian. But when I called that church on Broad Street, I was assured that their minutes from that period reveal no such wedding.

Pastor Ickert and I began speculating. Was there a mix-up over the fact that Resurrection is in the East Falls Church section of Arlington? I asked Palmer's staff to check again. I was preparing to leave the mystery open, stating with certainty only that the golfer got hitched somewhere within the circulation zone of the *Falls Church News-Press*.

But, lo, they called me back. Palmer's sister had confirmed that all the biographies are wrong. The secret wedding of one of history's top golfers indeed unfolded at Resurrection Lutheran. In Arlington. QED.

SCHOOL BOARD SEGREGATIONIST

What would we make today of 1950s Arlington school board member Helen Lane?

This one-of-a-kind education activist not only won appointment to the board in 1957 with a mission to prevent desegregation, but she also emerged as a friend to the American Nazi Party and its notorious local founder, George Lincoln Rockwell.

Yet she appears to have lived what, at the time, was a mainstream Arlington life.

Born in Illinois the daughter of a famous architect, Helen Scrymgeour Lane came to Arlington in 1951 with a BA from the University of Michigan and a teaching certificate. She was employed briefly at Marymount University and then worked as a treasury clerk while her son Robert was enrolled in the private St. Stephens Episcopal School.

Her first taste of the Arlington spotlight came months after the Virginia General Assembly in special session with Governor Thomas Stanley enacted its plan to resist the Supreme Court's 1954 order for school desegregation in *Brown v. Board of Education*. Arlington having had its power to elect its school board removed by Richmond, the county board picked the fifty-year-old Lane after she wrote to the *Daily Sun* of the need for a conservative.

Profiles in the local press revealed that Lane, when in her twenties, did not consider herself right-wing. But "as I gained experience, I became more conservative." She supported the anti-communist crusade of Senator Joe McCarthy.

Virginia's States' Rights Party backed her for the school board as a "godsend." In 1956, she had been among the 1,151 Arlingtonians out of 40,000 to vote for the States' Rights presidential candidate.

Lane was upfront about her goal of maintaining segregation by legal means. Board minutes show her focused on quality education and competition rather than on social issues. She backed "greater emphasis on personal excellence and less on group activity." American children "have been weakened by too many rights and too few duties," she said. She sought tight budgets—less spending on luxuries like audio-visual aids, and "no more palaces."

Once in office, Lane mocked "progressive education" and "professional educationists." Students "should be taught to do their tasks well—to learn the joy of, their tasks," she said, with "less emphasis on the pleasant aspects."

After her son transferred to Williamsburg Junior High, she caused a scandal by removing—with indelible ink—a personal comment on his report card written by math teacher Edwin Granger. She argued that it was unfair to have it on his permanent record. Lane failed to show up at the county board meeting that investigated the matter.

At the end of the 1950s, Lane was reported to be helping the fledgling American Nazis by duplicating their racist fliers on a press in her basement. (Homebuilder Barry Chamberlain, who later renovated her former home on Rock Spring Road, told me that he found no press.)

Lane went to law school at American University and became an attorney. When Rockwell was assassinated in August 1967, she represented John Patler, the fellow Nazi convicted of the murder. He pleaded not guilty.

To many, Lane seemed a typical middle-class Arlingtonian who liked music, antiques and gardening. Jean Dickson, who was married to the liberal state delegate Wally Dickson, told me that her then-husband became lunch buddies with Lane while they were in law school. "It's amazing that this woman, so nice and pleasant," Dickson said, "was a friend of Rockwell's."

Lane died on May 8, 1996, at age ninety in Shenandoah, Virginia.

CIVIL RIGHTS PIONEER

In the lead-up to Martin Luther King Jr. Day in 2014, I heard a talk by an Arlingtonian who personally shared some dangers of King's civil rights struggles.

Joan Trumpauer Mulholland is best known as a young white woman at the 1963 lunch counter confrontation with racists in Jackson, Mississippi. But her 1950s youth in Arlington did much to mold her into a nonconformist Freedom Rider.

At the January 13, 2014 talk organized by the Arlington Central Library and Encore Learning, Mulholland was joined by M.J. Obrien, author of a book on the Jackson event, *We Shall Not Be Moved*. He showed a portion of the recent film on Mulholland called *An Ordinary Hero*, produced by her son Loki.

Mulholland recalled her childhood as a member of Little Falls Presbyterian Church and the time it first invited "colored" children to a spaghetti dinner. She clashed with her parents, who insisted she attend Duke University when she preferred a more progressive religious school. "I was told by my mother that blacks were inferior, smelly, diseased and that white people rule," she said.

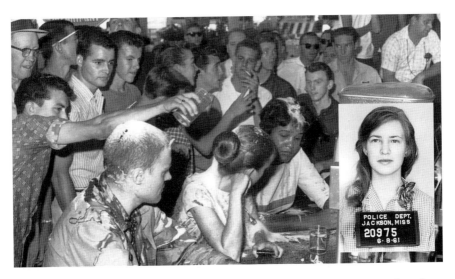

Police mug shot for Joan Mulholland. She and her compatriots risked violence and mockery.
Mississippi Department of Archives and History; Watch the Yard.

By age nineteen, Joan displayed a mind of her own. She joined Howard University youth in the Nonviolent Action Group. In June 1960, thirteen "bible-reading students" successfully challenged the whites-only lunch counter at Cherrydale Drug Fair.

At Duke, Mulholland clashed with deans over race questions, and a European trip paid for by her parents failed to alter her course. She joined Freedom Riders in Mississippi and was soon arrested for breaching the peace. She spent two months in hellish conditions at Parchman State Prison Farm.

Mulholland then transferred to a tiny black college, Tougaloo. "The northern civil rights activists were political, the southern ones religious," she recalled. Her parents refused to pay tuition, so she obtained a scholarship and worked a campus job for forty-five cents an hour.

The civil rights pioneer worked alongside Medgar Evers, planning the sit-in at the Jackson Woolworth. Tactics of the group were known in advance by FBI agents, who can be seen in photographs of the event watching passively "in dark glasses," explained Obrien. As the protest turned violent, Mulholland was grateful for the news cameras. "The press takes your story to the world."

Arlington, meanwhile, was taking some time to change. Mulholland's co-panelist, retired principal Sharon Monde, described being one of the first

black students at Swanson Junior High (class of 1965). Her mates from Halls Hill were told that "white people don't eat fried chicken with their hands," so they practiced using a fork. Monde recalled ordering hot chocolate at the Lee Highway People's Drug, but not sitting at the counter. She was puzzled why she couldn't catch a movie at the nearby Glebe Theater and instead took the No. 3F bus downtown. Her mother told her, "We want you to have a city experience." Mount Olivet Methodist Church was the only one that permitted blacks at teen dances, she said.

As an adult, Mulholland worked for federal agencies and as a teacher's assistant in Arlington, where she raised her five boys.

In 2014, she was keynote speaker at Arlington County's King Day celebration.

I asked Mulholland about her relationship with her mother in later life. "She was a good grandmother," Joan replied. "But on her deathbed at Fairfax hospital, she cried, 'They got me in the colored room!' She checked out of a world that had moved beyond her."

HOBNOBBING WITH COLONEL SANDERS

Colonel Harland Sanders—Kentucky hero, creator of the eleven-spice secret to "deeee-licious" chicken and today a global icon—cut quite a swath through Arlington.

I know, because I met the goateed charmer in his white linen suit on the Little League football field at Barcroft Park around 1963, when he ambled out, cane in hand, to cheer his franchise-sponsored team.

But the food icon's deeper Arlington connection goes back to the mid-1950s, when he journeyed here regularly to cook up the first D.C.–area Kentucky Fried Chicken franchise.

The local entrepreneur was Jim Matthews, who launched Tops Drive-In in 1953 and expanded it to eighteen eateries in the region. He did it on a $10,000 investment bet initially on the Sir Loiner hamburger.

In his privately published 1996 autobiography, Matthews tells of opening the first Tops at Route 50 and Glebe Road (it is now a McDonald's), offering emblematic "teletray" ordering by intercom from the car, to which a uniformed carhop would deliver the food. With advertising on WEAM radio, Tops by 1958 was serving 200,000 customers a month, half of them teens.

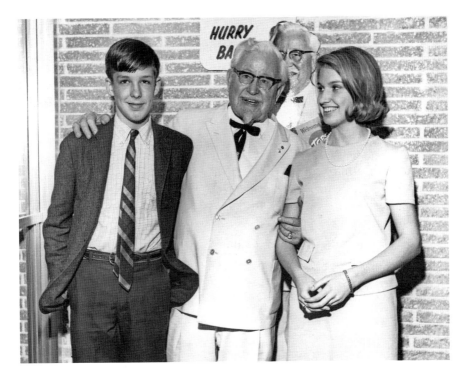

Jim Matthews Jr. with sister Jan and a celebrity. *Matthews family.*

Tops's progress was monitored by Marriott-owned rival Hot Shoppes (which would compete with Pappy Parker's fried chicken).

Around 1955, a representative from Kentucky Fried Chicken visited the Tops at George Mason Drive and Lee Highway (now a Capital One Bank) for a cooking demonstration of how to make things "finger-lickin' good." Matthews was unimpressed, preferring his staff's chicken. But he heard that the colonel was appearing at a restaurant show in Roanoke, so Matthews and his wife drove down and invited him to their room.

"I was still a bit dubious of the colonel," Matthews wrote. "He had a very ruddy complexion and in those days, who wore a white suit and a string bow tie, moustache and goatee, and carried a fancy cane?"

They served him bourbon without knowing he was a teetotaler. Sanders explained that the reason the test chicken had emerged as "a greasy mess" was that Matthews lacked sufficient BTUs in his gas range. Matthews shook hands on a ninety-day option for the KFC rights in Virginia, Maryland and Washington.

An artist created drawings of the colonel posing with the Tops boy mascot and the Washington Monument. The accompanying text read, "I'm bringing something great to Washington." Though Matthews buried the ads mysteriously in the back of newspapers, KFC took off. In the first weekend at eight Tops locations, he sold 10,000 buckets at $2.99 each.

"People knew who the colonel was real fast," recalls my boyhood friend Jim Matthews Jr., the model for the Tops boy and now a partner in a nightclub. Sanders was a frequent guest in his Bellevue Forest home. Both father and son tell the story of how Colonel Sanders took an eleven-year-old Jim Matthews Jr. in his Rolls-Royce for a ride on Kentucky's I-64. "Doesn't your dad ever let you drive?" he asked the boy, whose driving experience then was limited to go-carts. Sanders put him behind the wheel, and Jim was nearing one hundred miles per hour before the colonel thought better of it.

Kentucky Fried Chicken, meanwhile, had grown to six hundred outlets by 1963, becoming America's largest fast-food operation. "I can honestly say that Colonel Sanders and I have a great relationship," Matthews wrote. Although Matthews heard him "really chew out others of his KFC family… never did he say an unkind word to me."

CHERRYDALE THROUGH AND THROUGH

In my boyhood neighborhood of Cherrydale, there's a name renowned for decades as a volunteer firefighter, shopkeeper, Christmas party Santa and repository of local history.

Marvin Binns, seventy-nine, may have spent more time than any living soul at the early twentieth-century Cherrydale Firehouse (before it was rebuilt and modernized two blocks up Lee Highway in 2011). He was there when it still housed Sam Torrey Shoe Service (before Sam moved up Lee Highway in the early 1960s).

Binns's functioning fire truck, with which he delivers fire department mail, sits with permission in front of the Ballston apartment where I interviewed him in 2014. I was pleased to compare notes with a Cherrydale homeboy who preceded me by a generation.

As a blood-deep Arlingtonian born in Ballston, Binns attended Cherrydale Elementary School in the 1940s. He fondly recalls his favorite teacher, Mrs. Shin, three decades before the school's pair of buildings were torn down to house the Cherrydale Health and Rehabilitation Center.

From homes on North Twenty-First and later on Nelson Street, Binns at age eight went to work as a shelf-stocker at the old Shreve's Market, near what today is Mattress Warehouse. He recalls using the store's ice blocks to sell flavored ice treats and the time he and two pals chipped in and bought a package of Brown's Mule chewing tobacco. "We didn't know you weren't supposed to swallow it," he said.

Binns joined Arlington's fire team at age eighteen, though he soon enlisted for a four-year stint in the navy. He spent many nights sleeping at the firehouse that still stands as a state historic landmark. The department was like a family. One Christmas, his boss asked him to come down and answer what turned out to be false alarms, but, by this time a father, he begged off, saying he had to assemble gift bicycles for his children.

His volunteer firefighting was seldom dangerous, Binns said. He rememberd one close call in Lyon Village, when the rear of a long fire engine whipped in a sudden turn to avoid a woman in the street. "If I'd been sitting on the back I'd be gone," he said. In serious fires, such as the damaging blaze at the Murphy and Ames lumber yard in 1951, volunteers helped only from a distance.

Marvin Binns wowed Cherrydale as Santa. *Kathryn Holt Springston.*

Sundays in the 1950s Arlington was especially busy for firefighters in Rosslyn, Binns said. An industrial laundry, which cleaned clothing brought on Potomac River barges for a nearby oil refinery, stored the greasy rags over the weekend, and they combusted. The same was true at the nearby Jack and Jill diaper service.

Binns worked at Arlington Paper Company, which then stood alongside a penny candy store (now a Filipino market) on Monroe Street, near the old Ellis Radio. We both recalled the proprietor, Mr. Waller, selling licorice strips and dots of candy on paper for a penny.

He remembers the predecessor of the Cherrydale Safeway named Sanitary Grocery, as well as several sites Safeway occupied. He confirmed my recollections of Bernie's Pony Ring, which offered live pony rides at Lyon Village and Bailey's Crossroads.

Now battling an illness, Binns gave up playing Firehouse Santa for Cherrydale children—after thirty-seven years. He and his wife of fifty-five years, Betty, enjoyed their fifty grandchildren and great-grandchildren. Marvin was recently named by his community as Cherrydale's best volunteer.

Marvin Binns died in December 2015 at age eighty.

FEMALE POLITICAL PIONEER

Women in public office. It may seem normal today. A case in point is the Arlington School Board, which in 2015 had four female members out of five total. The county board's five members include two women.

But it was not long ago when "women made the coffee and the men ran for office," I was reminded by longtime Arlington political activist Vivian Kallen, herself an early distaff candidate for state delegate in 1969.

Kallen chalks up progress to the legacy of the late Kathryn H. Stone, a "legendary figure in the history of Arlington County and the Commonwealth," as it was phrased in a resolution commemorating Stone's achievements passed by the general assembly in February 2001.

Today, Vivian Kallen worries, Stone risks falling into obscurity because of a "vanishing" generation of citizens who knew her and appreciated her courage.

As the first female state delegate from northern Virginia, Stone spent twelve years (1954–66) battling the Byrd machine on the poll tax, rural domination of apportionment and the state's "massive resistance" to Supreme Court–ordered school desegregation.

Pioneer Virginia legislator Kathryn Stone. *Iowa Women's Archives, University of Iowa Libraries, Iowa City.*

Urged to run by Arlington attorney and civil rights leader Edmund Campbell, Stone braved her way to defending the NAACP's lawsuits. "She received threatening phone calls, and legislators got off the elevator when she got on," said Kallen, who once helped arrange an exhibit on Stone at the Arlington Central Library. "She took it all and never backed down."

Before moving to South Arlington's Ridge Road neighborhood, the Iowa-born Stone established herself as a theorist by co-authoring two books on the city manager form of government. As an organizer in 1944 she became the first president of the Arlington/Alexandria League of Women Voters.

When the segregationists were defeated in the late 1950s, Kallen said, Governor James Almond summoned Stone and said, "I've lost this battle, so help me make constructive use of this situation."

Stone also worked on JFK's Presidential Commission on the Status of Women, later seeking funding for health, education and mental health. In Richmond, she introduced a bill to establish a Virginia Commission on the Status of Women. It failed, but nonetheless it prompted Governor Albertis Harrison to create such a body.

Stone became a plaintiff in a 1964 Supreme Court case challenging Virginia's reapportionment plan, which gave rural areas more seats than heavily populated urban areas.

Using her local government expertise, she helped launch Virginia's first regional planning commission, which became the Metropolitan Washington Council of Governments, Kallen notes. She also served on a commission to create Arlington's merit personnel system, the state's first.

"Kathryn had a sharp intellect but was no glad-hander," recalls Kallen, who taught political science at Northern Virginia Community College. Former county board member Joe Wholey called Stone a "giant, and I feel she was head and shoulders above 90 percent of the people in public office today," Kallen adds.

When Stone died in 1995, at age eighty-eight, "there were not many buildings to name after her," Kallen said. "Honoring her would tell us a lot about our community, our history, about times we'd rather forget." Stone's papers are in the Special Collections Library at the University of Virginia.

The late Arlington County Board member Ellen Bozman called her "the mother of us all." But Stone's legacy reaches beyond liberal Democrats. In January 2015, the new representative to Congress from Virginia's Tenth District was conservative, Republican and female: Barbara Comstock.

NICHOLAS HAMMOND, GLOBAL THESPIAN

The Sound of Music costar, actor
Nicholas Hammond. *Publicity shot.*

If you marked the fiftieth anniversary of *The Sound of Music* in 2015 by watching the movie, you laid eyes on a star who grew up in in Arlington.

Nicholas Hammond, who played Friedrich von Trapp, went on to a long career in film, TV and stage as an actor, writer and director. Even before he sang in those disciplined formations with Julie Andrews, the child actor had performed in the film *Lord of the Flies.* He would appear as a TV regular on *Gunsmoke* and *Dallas* and had a starring role on *The Amazing Spider-Man.*

When I reached him by e-mail at his eight-acre spread in Sydney, Australia, Hammond was happy to recall his formative years attending Arlington's Jamestown, Williamsburg and Yorktown schools.

"I loved growing up there, in a much simpler time," he said, recalling homes first on North Twenty-Eighth Street and then Albemarle. "My brother and I had paper routes" for the *Washington Post* and the *Evening Star.* "Your parents thought nothing of kids going off on their bikes pre-dawn and throwing papers onto front-door steps. We'd play ball, or go on our bikes or explore the woods. It all seemed very safe."

Hammond's first theatrical experience was playing a rabbit in *Hansel and Gretel* at a school in Maryland, followed by narrating a Thanksgiving pageant. "My brother and I staged mixed-media performances at our home, which always seemed to end with putting kids in the wheelbarrow and taking them on a thrill ride," he said.

At Jamestown Elementary School, he performed in "Stuart Little." (His classmate Steve Lay, now a consultant in Falls Church, Virginia, recalls going to Hammond's home to rehearse and how his friend "Nicky," as the years went by, would regularly go away to act and then return in a new grade.) At Williamsburg Junior High, Hammond acted in *The Mouse that Roared.*

An influential teacher Hammond remembers was his sixth-grade instructor "Miss [Lois] Rettie." She was likely responsible for the warm

good-luck card signed by classmates that Hammond received when he arrived in Puerto Rico to film *Lord of the Flies*, a ten-week commitment that caused him to miss graduation.

Like any Arlingtonian of the period, Hammond has memories of Robertson's Five and Dime, Nachman's bicycle store and "Saturday matinees at the Glebe movie theater, probably where I saw my first movie, *The Wizard of Oz*. The witch throwing the fireballs was too much for a four-year-old," he said, "and I ran up the aisle to the lobby where my brother fixed the problem with a grape soda."

Hammond attended Yorktown High (class of 1967) for a year before transferring to Bethesda's Landon School, where his father taught. Then, at seventeen, it was off to Princeton and a career in the limelight.

Hammond returns to Arlington once or twice a year. His mother lives near Rock Creek Park and his brother across the Potomac in the Palisades.

The anniversary of *The Sound of Music* kept Hammond busy with greetings from old friends and fellow cast members. "I have done appearances for 20th Century Fox and Rodgers and Hammerstein in Hollywood, Salzburg and Sydney," he said. He paired up with Andrews for a southern hemisphere tour that included showings of home movies his mother took on the set. He then performed in a Rogers and Hammerstein concert with the symphony in Sydney in June 2015.

A Beauty Queen Tied to Dean Martin

Whatever became of Arlington's most famous beauty queen?

A reader slipped me clippings from the old *Washington Star* and *Alexandria Gazette* reporting the pulchritudinous triumphs of Gail Renshaw, who in 1969 was named Miss USA-World.

At the time, Gail Renshaw was en route to London to compete to be Miss World (she won first runner-up). But there would soon be the small matter of her engagement to world-famous crooner Dean Martin, a married man thirty years her senior. It seemed a tale worth running down for an update.

Renshaw, who graduated from Washington-Lee High School in 1965, grew up at 1711 North Seventeenth Street, as reported by the *Star*, whose male writer provided, in his fourth paragraph, her measurements: five-foot-eight, 39-25-37.

Local girl Gail Renshaw makes good with Dean Martin. *Peter C. Borsari/© Borsari Images LLC.*

I reached Gail Renshaw Blackwell by phone at the home she shares with her retired banker husband in Parrish, Florida.

A young ballet and tap dancer who by fifteen was teaching ballroom at the old Arthur Murray's in Arlington, Renshaw was a teen model. She appeared as "Miss Good Grooming" for the National Institute of Dry Cleaning, was queen of the Washington International Ski Show and posed for an auto show for $100 for a couple of hours' work.

After an early marriage and divorce, she was twenty-two when she hit the national pageants and traveled to Las Vegas. (A promoter named Sidney Sussman told the *Star* he "discovered" her on a Potomac River cruise, but Renshaw told me he was just a nice friend trying to capitalize on her fame.)

Martin, then fifty-three, was easing off the peak of his Rat Pack popularity but still hosting his own TV show and selling millions of middle-brow records. He was also separating from Jeanne Biegger, the second of what would be three wives.

"I really wanted to meet his daughter Gail, herself a good singer," Renshaw told me. Having seen Martin's live show and chatted at a photo session, she went for a drink at Dino's Den bar in Vegas's Riviera Hotel. It wasn't long before Martin asked her on a date. "Well, I have a chaperone," Renshaw told him, but Martin's daughter said she could fix that. Soon her chaperone was Dean Martin, and the next night, his daughter was conveniently unavailable.

The two fell fast, and Martin's daughter encouraged Renshaw ("You'd make my dad very happy.") The singer "was always considerate about his wife and family, who gave me a wonderful reception," recalls Renshaw. "Men loved him, and women loved him."

But after a few days of anguished phone calls, Renshaw told Martin face to face that she couldn't go through with the marriage. "The age difference was a hindrance, and I felt bad missing my parents," Renshaw said, noting that her father back in Arlington wouldn't fly on airplanes.

The retired beauty queen then moved to Prince George's County, Maryland, where she studied and became a registered nurse, specializing in dialysis. She and her husband, Bobby, built a house, dabbled in contracting and raised a daughter.

Renshaw today earns income as a certified gemologist, plays video games and enjoys her three grandchildren (the eldest resembles her). At one W-L reunion, she recalls, she sat all evening with "a family" of classmates she'd been with through Wilson Elementary and Stratford Junior High.

Is she still beautiful? I asked. Her demure reply: "Some people say so."

GENERAL ROWNY AT ARLINGTON CEMETERY

I was riding the tourist mobile at Arlington Cemetery in October 2014 when I chanced to notice an elegant tombstone bearing the name Edward Rowny.

I recognized him as the decorated army general who headed President Reagan's team negotiating strategic arms limitations with the Soviet Union in the 1980s.

Fast-forward to November 2014, when I attended the author's night/ book fair at the National Press Club. Standing before me at a reception was a ribbon-bedecked General Edward Rowny himself, there to sign his memoir, *Smokey Joe and the General*. We chatted and arranged for him to tell me the story of his relationship both with Arlington Cemetery and his former hometown of Arlington County.

Rowny's book is both an autobiography and a biography of his first boss, John Elliott Wood, "considered the best trainer in the Army," he writes. Wood's mentoring enabled the rise of Baltimore-born Rowny, a Polish American, to the top of the military establishment under five presidents.

The roots of Rowny's hawkish foreign policy were sown in the 1930s, when, as a student at Johns Hopkins University, he spent a year abroad in Poland. A side trip to Berlin brought him to the 1936 Olympic Games, where sprinter Jesse Owens won four gold medals. "I became terrified of the Nazis," he told me.

He won a slot at West Point in 1937 and, just after the 1941 attack on Pearl Harbor, found himself in the first U.S. Army unit sent overseas. He fought at the boot of Italy from 1942 through V-E Day.

With the war over, Rowny ended up as a planner for General George Marshall. He later became chief of staff to General Dwight Eisenhower and, during the Korean War, was a planner and spokesman for General Douglas MacArthur. "Wood and I rated the top generals," Rowny said. Their system put Marshall on top with eight or nine points, followed by Ike and MacArthur tied at seven.

"The highlight of my career came during the Vietnam War," Rowny said, "when we brought the first armed helicopters into battle, which was controversial," because low-flying vehicles were vulnerable to being shot down. Now their use is standard.

Perhaps Rowny's biggest splash was when, having become President Jimmy Carter's chief nuclear arms negotiator, he walked out in 1979, calling the pending treaty "unequal and unverifiable." He worked for candidate Ronald Reagan, ending up as Reagan's SALT negotiator and roving ambassador. That allowed him to meet seven times with Polish-born Pope John Paul II.

Meanwhile, his intermittent stints in the Washington area made him an Arlington resident. He chose Aurora Hills, near the Pentagon, with other

military brass as neighbors. Rowny became active in the nearby Arlington Historical Society, donating his grandmother's typewriter and steam flatiron as artifacts.

Now retired in the District of Columbia, Rowny works with the I.J. Paderewski Scholarship fund, named for Poland's "George Washington."

When I asked about the tombstone in Arlington Cemetery, near the JFK grave site, Rowny explained that his first wife has been buried since 1988 "in that beautiful spot." When he was dating his eventual second wife, another military wife at a cocktail party told him that her own husband lay in the cemetery under a stone where she, too, would rest. "Wouldn't it be wonderful," she said, to the dismay of Rowny's date, "if we could be lying next to each other?"

CARUTHERS THE DEVELOPER

Preston Caruthers seldom puts his name on the many marks he has made on Arlington over seven decades—an exception being chiseled letters on Caruthers Hall at Marymount University.

In his late eighties, the builder, multi-hatted civic leader and philanthropist still arrives daily at the Ballston office of Caruthers Properties LLC, though because of a heart ailment, his son Steve drives him. "I still cut my own grass," said the mild-mannered impresario.

Caruthers, whose contributions to the Arlington skyline include Dominion Towers, Shawnee and Rosslyn's Ames Building, lent me his private autobiography. It's a stark tale of how an Oklahoma farm boy whose parents died young survived the Depression through hard work but an incomplete education.

World War II cut short his high school days, but the navy trained him as a medical corpsman in the Pacific. In August 1945, Caruthers was on a ship awaiting orders for the invasion of Japan when the atomic bomb altered the fate of millions.

His sister's marriage to Arlington engineer George Snell brought him to postwar Washington, where he talked his way into George Washington University. But building soon distracted him—though neither he nor his brother-in-law had built houses. Beginning with his partner's lots in Lyon Village, Caruthers's first home project on his own was at 1800 North Inglewood Street. By the early 1950s, he was constructing seventy-eight split-levels off Sleepy Hollow Road.

Developer/philanthropist Preston Caruthers. *Caruthers family.*

Then came his turning point. With postwar tax rates at 70 percent, he foresaw more profit in vertical apartment buildings. His biggest was along Shirley Highway (I-395). In 1960, aerial photos prove, few structures dotted the area between Seminary Road and the Pentagon. With partner Mark Winkler (later of the Mark Center), they built over four years Southern Towers—twenty-four hundred units in five buildings.

Caruthers recalls defeating gun-toting "labor goons" in a unionization vote. "The Kennedy-Johnson-Vietnam war years rent asunder the unity and crushed the esteem of the American people," he wrote. "However, it was our most economically productive period."

In 1963, while heading the chamber of commerce, he sought to integrate the chamber. To those gathered at Washington Golf and Country Club, Caruthers spoke for racial inclusion, but Chevrolet dealer Bob Peck tabled his motion.

Caruthers created office buildings and cultivated government tenants from the General Services Administration and CIA. He gave land that became Rosslyn's "St. Exxon," the Methodist church over a gas station.

In 1968, the conservative Caruthers was appointed to a liberal school board with "a budget in the thousands," he joked. He lent his building expertise to the construction of a new Thomas Jefferson Junior High.

This determined dropout went on to serve on the state board of education, advised fledgling George Mason University and traveled the state on behalf of private colleges. His donations would benefit the Arlington schools' planetarium, Gulf Branch Nature Center and Glebe House (which he bought from the late state senator Frank Ball, renovated and gave to the National Genealogical Society).

Caruthers still meets weekly with notables at Washington Golf to influence civic affairs. His grandchildren, meanwhile, are taking over his company. (Its current big project is Belmont Bay near Occoquan.)

Homebuilders today use less brick and more frames, Caruthers said. But he now sees Arlington houses as secondary in beauty to the trees. "Today

I drive and see one of the most beautiful places one could live in," he said. "It's breathtaking."

In 2016, Caruthers was dragged into a community dispute over a sign he had erected when he built a gated community in the mid-1980s near the Madison Center on North Stafford Street. In what a local blog called "seriously outdated lingo," the plaque referred to the homes as a "sanctuary for wildlife and not so wildlife…at the historical site of the Civil War Fort Ethan Allen, which commanded all the approaches south of Pimmit Run to Chain Bridge during the War of Northern Aggression."

That language, I learned from the Caruthers family, is not as militant (i.e., "The South shall rise again") as it appears. Its reference to the "War of Northern Aggression" was intended by Caruthers as a humorous reference to the "wildlife" who inhabit the homes. He issued a clarification to apologize for any misunderstanding.

German American Jazzman

A jazz maestro who honed his rhythms in Arlington found himself coming full circle in May 2015 at the Washington Golf and Country Club.

Lennie Cuje, a revered vibraphonist who was raised in Nazi Germany but grew up to perform at special events for three U.S. presidents, spoke on May 19, 2015, at the Host Lions Club luncheon. The last time he had enjoyed that spectacular view of the D.C. skyline, the eighty-two-year-old noted, was a 1956 performance for the Rotary Club.

The luminary modestly spun tales of his encounters with Lionel Hampton, Louis Armstrong, Miles Davis and Larry Coryell.

Cuje (the name is Belgian French) was born to musical parents in Giessen, Germany, on the eve of Hitler's rise to power in 1933. His mother was an opera singer, his father a pianist and symphony conductor. As a child, he found himself in elite Nazi music schools for piano, voice and trumpet.

"I was nine years old in 1942 when I was required to join Hitler Youth," Cuje said, which meant an oath of being "born to die for Germany" at the height of World War II. By age twelve, he was drafted by the SS, training with an "MG-42 machine gun and one hundred rounds of wooden ammo," he recalls.

In April 1945, he became a prisoner of the French and spent two weeks in a convent with kind nuns. In a displaced persons camp, he got his first taste of the strange music called jazz—which he took to be African but

An escapee from Hitler who wowed jazz clubs. *Lenny Cuje.*

learned was American. It became his "music of freedom."

An aunt at the U.S. Justice Department brought Cuje to the States in the late 1940s, where he settled in the East Falls Church neighborhood. By now a solid English speaker, Cuje enrolled as a junior at Washington-Lee High School, graduating in 1952 with Shirley MacLaine. At the prom at the Shoreham Hotel, Cuje and a buddy brought dates who were black. As expected, they were turned away. They spent the evening at jazz clubs.

Summoned to the air force, he traveled to New Mexico in an atomic unit for the Korean War. Back in Arlington in 1956, he worked for Moser's Pharmacy in Clarendon. It was the pharmacist who moved him to Johnson City, Tennessee, with the business, with Cuje enrolling at East Tennessee State to study harmony, theory and counterpoint.

"I was one of the few whites on the chitlin' circuit," he said, which became an issue when he performed in Washington's U Street clubs. In New York City, he played for more than a decade with jazz's best, but he became a drug addict. By 1979, "I left all my vices behind, except for women," said the thrice-married Cuje.

He entered homebuilding. With help from Arlington Cultural and Social Services, he brought music to schools. Soon he was performing with the Navy Jazz Band at the Kennedy Center.

He played inaugurations and campaign concerts for George H.W. Bush, Bill and Hillary Clinton and Barack Obama. But hauling his vibraphone in three large pieces was exhausting, he said, and with Secret Service rules, preparation involved "six hours to play one tune."

Today, Cuje is semi-retired, living near the Lee-Harrison Shopping Center, performing as he chooses in a much-changed Arlington. As he told the Lions, "The county club is bigger than it used to be."

In late 2016, he was treated to an astonishing reunion with a fellow German music student with whom he had lost touch for seventy-one years.

In May 1945, as starving twelve-year-olds after the Nazi government's collapse, they had walked across Germany together looking for their families. They tearfully separated. Seven decades later, nuns from a German convent matched them up and put the two in touch. That led to a week's worth of recording in Cuje's Arlington home for a German radio documentary of their reunion.

Our Grimmer Side

Brothel-Keeper Mary Hall

When some good students from Marymount University presented their campus history in 2015, I noticed that they omitted mention of one seminal figure.

Mary Ann Hall was of the most successful prostitutes and brothel keepers in the nation's capital in the nineteenth century. Her ill-gotten wealth enabled her to purchase a country farmhouse in what then was Alexandria County on land that would become Marymount and the Washington Golf and Country Club.

What an Arlington family! Mary's brother was slave owner Bazil Hall, whose plantation off modern-day Lee Highway became Halls Hill. Her other brother, John, shows up in the post–Civil War Southern Claims Commission 1880s proceedings seeking to sabotage Arlington farmer John Febrey's effort to collect compensation for his livestock and crops taken by Union troops. (Rebuttal testimony questioned Hall's character, noting the profession of his sister.)

Mary (born circa 1817) made her fortune in a twenty-five-room red brick house of ill repute within sight of the Capitol (the site today of the National Museum of the American Indian). "In the 19th century, brothels were part of the urban fabric of city life, especially in Washington, D.C. with its transient population of soldiers and government workers," *Smithsonian* magazine wrote

in 2005. "Prostitution was not officially a crime, and during the Civil War, there were 500 registered brothel houses and over 5,000 prostitutes in Washington."

Hall's establishment, ranked No. 1 in a brothel survey, hosted nineteen female "inmates." Its upscale ambience was revealed in a fruitful archaeological dig in the 1990s. An inventory listed plush Brussels carpets, oil paintings, china vases, marble-topped tables, a marble clock, a mirror-fronted wardrobe and all manner of mattresses, comforters and pillows.

Mary's downtown place was raided in 1864. Despite her high-priced lawyer, she was convicted of "keeping a bawdy house" and paid a $2,000 fine.

Her Arlington property of eighty acres was purchased in October 1853 from the Birch family for $2,400, according to Willard Webb's fine 2004 article in *Arlington Historical Magazine*. Called Maple Grove, the two-story structure with a taller central tower was improved and assessed, according to 1863 tax records, at $16,000. Union soldiers en route from Chain Bridge passed by it and took supplies and water from the spring. (Hall would later successfully apply for compensation.) With her sister running the downtown parlor, Mary was, by 1880, spending enough time in Arlington to be listed in the Alexandria County census.

She died in 1886 after a two-week illness (her death certificate omitted her occupation) and was buried under a stunning monument in the prestigious Congressional Cemetery. Her siblings fought over her estate (she left no will), so trustees auctioned the Arlington property—now ninety-two acres—to Colonel William B. Brocket of Louisiana for $9,700. In 1888, it was bought by Admiral Preston Rixey, who, after Hall's farmhouse burned in 1907, built his mansion and then sold land to the country club. (Mary Hall's spring and a shelter survived near the golf course's fourteenth green until 1959.)

Hall's obituary in the *Evening Star* editorialized, "With integrity unquestioned, a heart ever open to appeals of distress, a charity that was boundless, she is gone but her memory will be kept green by those who knew her sterling worth."

Were that the whole tale, today's Marymount students might feel a bit prouder.

ARLINGTON'S BRUSH WITH THE KLAN

Hungry for a vivid portrait of Arlington's seamier side?

You could do worse than the spooky website Our Redneck Past. Its blog posts by a non-bylined researcher unearth "lost fragments" of our less-than-

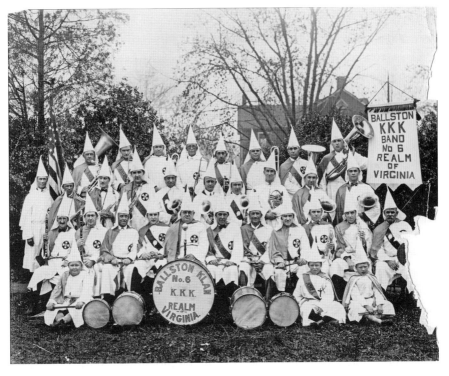

Race music enthusiasts from central Arlington. *University of Virginia Library, Special Collections.*

pleasant history—from motorcycle-gang bars to Ku Klux Klan parades, as well as more cheerful memories of country music haunts.

One entry describes the scene in March 1922, when 400 KKK members marched from Chain Bridge to Falls Church, passing through Clarendon, Ballston, Cherrydale and Rosslyn. The marchers carried signs reading, "We are for upholding the law," the account says. "Northern Virginia had about 60,000 KKK members in the twenties, which may have been as much as two-thirds of state membership, with the largest regional being the Ballston Klan No. 6." Our local chapter had its own marching band, sponsored a youth baseball team "and owned a field for cross burnings...at the current site of Ballston Mall."

According to a clipping from the *Evening Star* of December 22, 1922, dug up by Arlington Historical Society activist Annette Benbow, more than two hundred robed Klansmen gathered just before Christmas in a field before a fiery cross to initiate twenty new members. Four robed figures then drove to

the Salvation Army headquarters in Alexandria and presented the charity with a check for $1,100.

From Our Redneck Past, astonishing tidbits include a photo of robed Klansmen conducting a funeral in the Bon Air neighborhood, along with tales of bootlegging, gambling and friends in high places. "In Arlington alone, the Klan would claim…that 'practically every male voter in good standing is a member.' This was boastful swagger, but the fact that the claim could be made with a straight face proves the unnerving reality that Arlington was a Klan town," the narrator says.

Major Arlington figures such as Sherriff Howard Fields (served from 1924 to 1944) and Commonwealth's Attorney (and later state senator) Frank Ball are dragged in, their roles sometimes contradictory (Fields supposedly joined the Klan; Ball, a foe of segregation, accused its members of making false charges about his prosecutions).

For the 1960s and '70s, Our Redneck Past details murders involving the notorious motorcycle gang the Pagans. It criticizes the media for a "moral panic" about the state of local youth.

We get a list of "joints," or biker hangouts. Among the Arlington ones are Bull Run Grill at 6001 Lee Highway, the Classic Country at 89 North Glebe Road, the Covered Wagon at 1720 North Moore Street, JJ's at 501 North Randolph, the Keyhole Inn at 1126 North Hudson Street in Clarendon and the Royal Lee across from Fort Myer. A gang business card reads, "You have had the privilege to be stomped by the PIONEERS of Arlington, Va."

More upbeat is the poster promoting a 1966 concert from bluegrass kings Lester Flatt and Earl Scruggs at Washington-Lee High School. And there's a nifty account of famed folk music popularizer Alan Lomax, who had a house in Rosslyn in the late 1930s with future film director Nicholas Ray. Pete Seeger hung out there.

So who's behind this raw history? Keith Willis, a forty-something union staffer who grew up in Fairfax, assembles the material from his home in Westover. "I'm trying to explain to people, few of who come from around here, how different it was with all these muscle-car kids" roaming northern Virginia, he told me. "There's a rich history to be done" on gangs, organized crime, area hippie culture and the politics of the Prohibition era.

Having studied history in college, Willis devotes leisure hours reading old *Evening Star* clips on microfilm and online at the District of Columbia and Arlington Central Libraries. All for the satisfaction of between one thousand and two thousand visitors per month to the Our Redneck Past website. I commend his historian's eye.

Imprint of the Arlington Nazis

I've long felt that the strangest episode in Arlington County's history is the presence of the American Nazi Party here, from 1958 to 1983.

Even stranger is the way memories of the party's charismatic, racist and anti-Semitic founder George Lincoln Rockwell persist in the minds of longtime Arlingtonians.

My high school compatriot Sandy Harwell shared an astonishing recollection from his days as a second-grader at Nottingham Elementary School in the late 1950s. Walking to school on Williamsburg Boulevard, young Harwell would fall in with a "towhead" boy named Ricky Rockwell. "We became good friends and would walk home together," he recalled. One day, Ricky said "his mother had received a threatening letter and he wouldn't see me again. He and his mother and sisters were moving back to Iceland. He had never mentioned Iceland, and I was confused."

Older Arlington school kids also recall Rockwell's house on Williamsburg Boulevard with the eerie lights and swastika displayed in the picture window less than fifteen years after World War II. Mary Jane Regan, a Washington-Lee High School and Marymount student in the late 1950s, remembers seeing Nazis there distributing literature. Some of her friends went inside to hear their pitch.

Herman Obermayer, the onetime editor and publisher of the *Northern Virginia Sun* who was still active in Arlington until his death in 2016 at ninety-two, had a complicated relationship with Rockwell. As a Jew who witnessed the Nuremberg trials, Obermayer in the 1960s and '70s broke with much of the media that sought to avoid giving publicity to the Nazis. Obermayer thought they should be exposed.

The retired editor and author told me that Rockwell was a "stumblebum." His *Sun* editorials mocked the Nazis for claiming that the Internal Revenue Service acted unconstitutionally when it evicted them from their house on North Randolph Street. The *Sun* published letters from Rockwell denying he was a violent threat but addressing "the negro problem."

In one personal letter to Obermayer, the commander said he was "nonplussed" that his letter was published. "I was told by a member of your staff…that you were a real villain, out to get me by any means, fair or foul," Rockwell said. "Now I have no idea what you are, what you believe, or what you are out to do. But I do know that you have been damn square with your paper—fairer than any other paper in the country."

Perhaps the most dramatic, if indirect, memory of Rockwell comes from my neighbors, the daughter and son-in-law of Polish Holocaust survivor Jan Komski (1915–2002). The Sullivans described to me the harrowing tale of how Komski, a talented painter, pulled off a daring escape from the Auschwitz death camp, where he had been brutalized. (He later recorded the horrific images he witnessed in paintings.)

After the war, Komski immigrated to the States and became a commercial artist for the *Washington Post*. His house on North Madison Street was just blocks from the Nazi "barracks" on Wilson Boulevard. This man who'd been victimized by real German Nazis got his hair cut at the same barbershop (Tom's) that Rockwell frequented.

According to the Sullivans, Komski never spoke of Rockwell—except once. On that August day in 1967, when news reports reverberated with the killing of the party leader at the Dominion Hills Shopping Center, Komski came home and told his daughter, "They shot the Nazi today."

The one remaining building occupied by the Arlington Nazis as a party is today one of Arlington's coziest coffee hangouts. The independent Java Shack offers dark liquid charms on Franklin Road near the courthouse.

When I popped by in August 2014, however, it was not merely to sip the brew, but also to consult the owner, Dale Roberts, as part of my ongoing study of one of our county's less-happy legacies: the presence of the American Nazi Party.

Roberts, who opened the coffee emporium in 1996, was aware of its past as headquarters for fifteen years of a clique of neo-Nazi propagandists who settled there after their founder, George Lincoln Rockwell, was murdered farther down Wilson in 1967. Roberts gets queries monthly.

"You'd think it would have died down by now," said Roberts, who owns the business but not the building he shares with a pet accessories shop and residents. But he cheerfully showed me the "New Order" business card he found on the premises. (Duplicates of the same one keep showing up anonymously in the central library's copy of the Rockwell biography *American Fuhrer*.) Roberts pointed out holes in the façade once used to display a swastika and the braces that held a Nazi flag.

Most vivid is the flier he found stashed behind a toilet with fading color photos of the unprepossessing Nazis posing out front, below a "White Power" sign as members of what, after 1967, was the National Socialist White People's Party.

It was from here in 1976 that these "patriots" marched in Arlington's Bicentennial Parade. And it was here on December 12, 1977, that they were

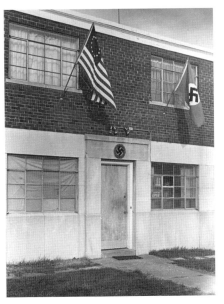

Nazi HQ near Arlington Courthouse, now a coffee shop. *Herman Obermayer collection.*

attacked by from thirty to forty D.C.–based anti-racism protestors, who were "hurtling rocks and eggs and scuffling" with the Nazis, according to the *Northern Virginia Sun.* Thirty cops arrived in twelve squad cars to break up the melee, with no arrests.

The Java Shack location was actually the fifth local site of the Nazi headquarters. A private home on Williamsburg Boulevard at Sycamore Street was where Rockwell in 1958 first mounted his well-lit swastika in the picture window. In 1960, the group moved to a donor-subsidized shack at 928 North Randolph Street (now Richmond Square Apartments), where they greeted Ballston neighbors with a sign reading, "White Man Fight! Smash the Black Revolution Now." The "storm troopers" were evicted in 1965 for failure to pay taxes. They stayed briefly on North Taylor Street (now the site of the National Rural Electric Cooperative Association).

Soon, they reassembled at their other "barracks" near Seven Corners on Wilson Boulevard. Known in the press as Hatemonger Hill, this house (now Upton Hill Regional Park) was where Rockwell was living when he was shot at the Dominion Hills shopping center.

In 1968, the party faithful moved up Wilson to Franklin Road (first renting, later owning). They would share the building with co-owner Lucas Blevins, a dentist and former county board member who called their presence "nauseating." Blevins's daughter, Beth Cuje, a local therapist, told me that her family was "disgusted" by these neighbors. "We were all amazed, it seemed so odd. My sense is my father had no power to stop it, and didn't know what was going on."

In 1983, the much-diminished Nazis, now called the New Order, packed up and moved to Wisconsin.

I assured Dale Roberts that in presentations I give on Arlington's Nazi experience, I always give a shout to the Java Shack as a much better use of the facility.

MOTORCYCLE GANG SHOOTOUT

Memories of Arlington's "night of gang warfare" pack a punch nearly a half century after the drama.

In March 2015, I had the privilege of addressing Arlington's Committee of 100 to share research I've compiled on that strange local flirtation with mass violence.

On June 14, 1966, just before midnight on a Tuesday, the tranquil suburban Lee-Harrison shopping center erupted in gunfire. Some one hundred shots were traded by rival motorcycle gangs. Astonishingly, no one was killed or even injured.

Like the sour presence of the American Nazi Party in our county from 1958 to 1983, the gang clash recalls Arlington's seamier side, from a time when alienated working-class whites made themselves visible in ways foreign to today's gentrified community.

I pieced together the story through interviews with police officers and front-page news accounts from the old *Washington Star*, *Post* and *Daily News*. I also had long talks with the central protagonist, Wayne Hager, then a meat cutter.

Hager fondly recalls his time hanging out at the old Tops Drive-In at George Mason Drive and Lee Highway, drag races near Walker Chapel, matching wits with state troopers and picking fights with boyhood playmates who were members of the East Coast gang the Pagans. The cause of the melee was tension between the dangerous gang and Hager, who would ride his Triumph to their gatherings but declined to join.

Fistfights between Hager and future Pagans president Frederick "Dutch" Burhans and another Pagan from Maryland followed. The latter was killed in a car wreck after his run-in with Hager, prompting Pagans to call Hager out.

They would rumble at "the lot," their name for the shopping strip then containing a Safeway, a Drug Fair and Gifford's Ice Cream. Wayne Hager quickly formed a new gang, the Avengers, and ordered jean jackets stitched with the name.

Police received a warning at 5:00 p.m. that afternoon, but Commonwealth's Attorney William Hassan said the law required a crime before anyone could be arrested. (Preemptive action would later become an Arlington police option.) The cops did detain two Pagans carrying sawed-off shotguns before the bullets flew.

The Avengers arrived with a 25-mm automatic, an AR15 rifle, brass knuckles, hunting rifles and clubs. As the police shift was changing, shots

rang out from behind Gifford's, prompting Hager to hit the ground as Pagan cars peeled by. Hager jumped in his Impala and sped home to dispose of guns before returning to help police, eventually pressing murder charges.

Police called it "the most shots fired in Arlington since 1865." The reason no one was hit, Hager maintains, is that the men weren't shooting to kill.

The county board split over whether the clash merited a crackdown on weapons and whether the board could meet on the subject without jeopardizing prosecutions.

About twenty gang members, ages eighteen to twenty-five, were tried for disorderly conduct and incitement to riot. Most received fines of from $100 to $250 or a sentence of thirty days in jail.

The rivals would later reconcile, though Dutch Burhans was shot and killed in 1980.

After I published on the subject, a former would-be Pagan wrote to say he'd been tempted to join the gang but is forever grateful his father insisted he go off to college.

At the Committee of 100, Rex Thomas, whose father was an Arlington police officer, showed up with an actual Avengers jacket, after all these years.

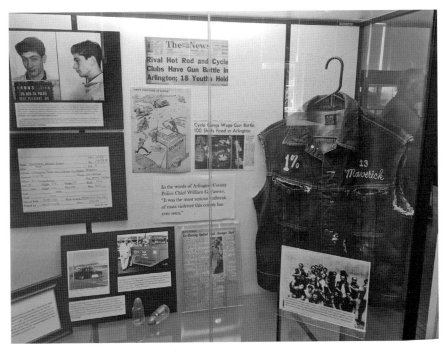

The 1966 suburban gang shootout prompted a museum exhibit in 2016. *Charlie Clark.*

In June 1966, to mark the fiftieth anniversary, members of the Arlington Historical Society recruited Hager to return to the Lee-Harrison parking lot and relive the drama. The historical society then mounted an exhibit.

AN UNRESOLVED NEAR-MURDER

In 2016, one of our county's most horrific crimes was, half a century after its commission, confirmed as an open case with the Arlington Police Department.

The brutal beating of Brenda Sue Pennington in January 1965 drew coverage for years from the *Evening Star*, the *Washington Post*, the *Northern Virginia Sun* and papers in her home state of West Virginia. Her surviving relatives petitioned to solve the mystery and identify the perpetrator.

Pennington was a nineteen-year-old from Quinwood, West Virginia, who worked in Rosslyn as a keypunch operator for Howard Research. On January 25, 1965, when she failed to show up for work, her supervisor contacted her apartment building at 1632 North Oak Street.

The door ajar, her boss and the building owner-manager entered her apartment and discovered the gruesome scene.

Pennington, wearing only a white sweater and bra, was half under the bed, unconscious. Upon examination, they could see that her eyes were black and swollen and that there was a two- by four-inch gash on her left temple. "A [mercury] substance was observed on the victim's midsection, uterus and upper legs," the police report stated. The phone was off the hook. After she was rushed to Arlington Hospital in a coma, her parents, Olive and D.S. Pennington, a trucker, made the eight-hour journey to hold vigil.

Their only child had been an attractive high school drama enthusiast and 4H Club member. Friends recalled that she abandoned small-town life and moved to Arlington for a career and social freedom. She was skilled enough to be teaching night classes at Temple School and frequented nightclubs downtown. Her landlady had promised her parents that she would look after Brenda's safety.

Her cousin Jim Pennington, who lived in the same building and who was interrogated by police, said Brenda wouldn't answer her door without the security latch in place. Neighbors saw her with a heavyset blond man.

Commonwealth's Attorney William Hassan hoped in vain to interview the hospitalized victim. He later confirmed evidence that she'd had sex, though

Brenda Sue Pennington before her tragedy. *Iona Dillard*.

the timing wasn't clear. Detectives determined that a TV was missing, as was a heavy wine decanter, the probable weapon.

Years of investigation with dozens questioned fingered no culprit. Brenda never recovered. She remained in a vegetative state requiring spoon-feeding and diapers. She was moved to a West Virginia nursing home. Russell Runyon, a detective on the case, contributed $500 of his own money to a fund for the family. "She's better off dead....Her parents have been through hell," he said in 1977.

Pennington depended on Medicare until her death in 2007. "She lived a horrible life," said her cousin Iona Dillard of St. Albans, West Virginia, who, in January 2016, filed a Freedom of Information Act request with Arlington police. "We would like to know why they didn't pursue it, if they looked further for suspects," she said. "We would love to have it solved, but it's not likely."

Brenda "had a strict upbringing and met new people in Arlington," said fiction author Amanda Summerbell, who is researching a possible book on the case. "It could have been anyone she knew."

In February 2016, Lieutenant Scott Linder of Arlington Police Internal Affairs wrote to Iona, saying that some of the report on Pennington cannot be released because it is "related to a criminal investigation."

LOCAL NARC EXPOSED

As marijuana use wafts its way toward respectability, I can't help recalling the pot scene in the Arlington of my youth.

For details of my own experimentation, you must visit a password-protected website with a hefty subscriber fee (kidding).

Anyone in North Arlington around 1970 could not have missed the flagrantly spray-painted graffiti that for years stained the underpass at Yorktown Boulevard and North Glebe Road: "Bill Welebir equals narc." That unsigned cry-out capturing the period's underground youth drama, it turned out, was accurate—as I learned from a 2014 online "confession."

Recreational weed, as remembered by anyone who in the 1960s listened to "Puff the Magic Dragon" (kidding again), circulated discreetly among high school kids who peer-pressured pals at parties to pass the pipe around.

Arlington police and their D.C. counterparts began keeping tabs. In 1970, William Wardell Welebir, the nineteen-year-old son of an

Arlington physician working at a department store, began offering law enforcement information on drug use in schools, in homes, even at a commune, according to a 1972 *Washington Post* account by current *Post* education columnist Jay Mathews. Welebir acted because he wanted to become a police officer, he later said.

Suddenly, the name "Welebir" was splashed on nearly a dozen walls, trestles and fences from D.C. to Chain Bridge and from McLean to Sycamore Street. Welebir began receiving threatening phone calls and getting in fights with teenagers to whom he had boasted of his undercover work. The home he shared with his mother was firebombed—twice.

It was a strange sign of the power of anonymous graffiti. (I don't recall that any of my friends who discussed Welebir did much independent fact-checking.) So Welebir fled to Harrisonburg for nine months, returning in 1972 to pose with his long hair for a news photographer in front of the immortal graffiti. But he had trouble finding a job in Arlington, and the police were soon regretting having relied on an inexperienced youth to report on his peers.

In June 2009, the online magazine *DCWatch* included a dispatch from Welebir, who had migrated to Front Royal and South Carolina. In the piece, he thanked police. "Back in the late 1960s and early 1970s, I worked for detectives out of what was then the 3rd District Headquarters vice unit, on 23rd and M Streets, I think," Welebir wrote. "Well, I'm old and terminally ill now and thinking back on the best times I had back then. They were going out and beating the streets of Georgetown and Northwest in search of marijuana and other illegal substances. Naturally, it was nothing like it has become over the years. We didn't have to worry about guns and big money, just about cleaning up the streets."

In 2010, Welebir was sentenced to five years in prison for burning down a Strasburg, Virginia biker bar.

7

VIVID MEMORIES

LOCAL GHOSTS

For Halloween 2016, I offered three fresh Arlington ghost stories, all from reliable sources. I report, you decide.

The first story involves Arlington Hall. Back when that white-columned edifice on Arlington Boulevard was a girls' school (1927–42), there was a student named Mary, last seen in a floral print dress. She became pregnant and committed suicide, as I was told by Jim Bernhardt, director of foreign language curriculum development at the Foreign Service Institute. According to the Arlington Civic Federation, the father was a stable hand.

When that U.S. State Department offshoot moved to the building in October 1993—following decades of occupancy by intelligence agencies—oddities unfolded.

Most staff came in early October, Bernhardt said, but a few arrived on Halloween. They heard "moaning and groaning," and soon, old-timers were discussing the "ghost of Mary." One year, a senior manager sent the staff an electronic party invitation reading, "The ghost of Mary invites you to celebrate Halloween."

One guest dressed as a schoolmarm. At the end of the party, the FSI staff locked the offices. The next morning, they entered to find the glass front of a bookshelf "shattered into small pellets," Bernhardt said. "We believe Mary was unhappy at her memory being treated with disrespect. Now we treat her with respect."

The author at ghostly Arlington Hall. *Leila Kamgar.*

But that wasn't the end. On another occasion, women using the fifth-floor restroom found the stalls locked from the inside. The space under the doors was too tight for an adult to crawl under, Bernhardt said.

In addition, a teacher of Southeast Asian languages at the institute died suddenly from disease. Soon, inanimate objects in her office began moving, and staffers heard noises. The noises continue, Bernhardt said, and employees avoid that office.

In North Arlington, the Overlee swim club community has long spoken of sightings of the ghost of Margaret Febrey, a resident of the club's nineteenth-century house (torn down in 2012) who died in 1913 at age fourteen. Overlee's resident manager told me directly that he's seen her.

Now comes testimony from a neighbor, Cecelia Allen, who teaches French at the H-B Woodlawn program. She says that Margaret may have been in her home. About the time that Overlee was demolishing the historic Febrey home for a new clubhouse, Allen was packing her sons off to school. In her dining room, she spotted the blurred feet of a figure dashing into the house. Assuming it was her son, she went out and left the door open for that son.

But when she got in the car, both sons were inside, asking why she had left the door open. "I sensed a clear presence, somebody ran by me."

More recently, Allen said, her TV, without a working remote, suddenly comes on. "It doesn't feel scary but comforting."

The third tale unfolded at the eighteenth-century home of George Minor, just over the Arlington border in Mclean. Marion Hardy LaRow, who grew up in the house in the 1970s, told me that her family often spoke of the ghost of Mary Minor. Back around World War II, LaRow's grandmother once bought new glassware and silverware and laid them out in the old kitchen. With no one else home, she walked away and returned to find the "new stuff gently stacked at the end of the table and the old glasses put out again," LaRow said.

Mary Minor's ghost became the subject of her siblings' sometimes scary childhood games. But in the fall of 2016, the home once visited by Dolley Madison was torn town by developers. Neighbors beware!

RETRACING MY CHERRYDALE ROOTS

I have one thing in common with Joan Hitt, matriarch of the construction company family (that's their name on Virginia Hospital Center's Family Center for Radiation Oncology): we both spent our childhoods in Cherrydale.

That deep-rooted but evolving Arlington neighborhood, she agreed with me, holds rich memories. Born in 1935 in a doctor's office where Brown's Honda stands today, the former Betty Joan Davis reminisced about her 1947 tenure as Cherrydale May queen. A photograph shows her as a twelve-year-old leading the parade on North Oakland Street.

That got me thinking. If I walked around my own Cherrydale boyhood haunts from the late 1950s, how vivid might my recollections be?

To be sure, I still visit this cozy corner of Arlington where century-old blue-collar Sears homes sit cheek-by-jowl with modern craftsman houses.

In 2015, I enjoyed a Christmas party in the decked-out Quebec Street home of Kathryn Holt, Scott and Dakota Springston, every inch of whose 1890 house is lined with historical artifacts, antiques and fun decorations. (Holt and I did first grade together at long-gone Cherrydale Elementary.)

But resurrecting ghosts from my formative years required more concentration.

My walk began with our old homestead on Monroe Street, which brought to mind an impromptu ice cream party I begged my mother to throw in the

then-open yard that now contains a house. The Stanton house next door was, in 1959, the site of a feud between current and previous owners over whether lumber stacked in the yard conveyed.

Across the street, I peeked inside the Cherrydale Bible Church, where we made lanyards in crafts class (even though it wasn't our Episcopalian family's church). I can still hear Reverend Hazlett on his adjacent front stoop singing "He's Got the Whole World in His Hands."

Next door on Monroe stands the brown-shingled residence of the Holmes family, whose large brood of children required the mom to set up a Wonder Bread assembly line to make sandwiches.

Farther east on Twentieth Street is a corner house in which I played toy soldiers with a kid who taught me to shout "Bombs over Tokyo!" only fifteen years after World War II. Down nearby Kenmore Street was the home of a first-grade girlfriend of mine who introduced me to a Danny Kaye recording of "Hans Christian Andersen." (I had misremembered her house as being on Lincoln but verified it in a 1960 directory at Arlington County Central Library.)

The well-remembered Cherrydale May Fair. *Hitt family.*

Also resurfaced was a memory of Saturday morning walks with my father all the way to the Clarendon Trust Bank. We had to clamber down the (pre–I-66) stairs to Kirkwood Road.

Moving west, 1625 Quincy Street was the home of an older kid nicknamed "Conrad the magician." He ripped me off by selling me a "magic wand" that was simply a pencil painted black and wrapped with adhesive tape.

The most intense memories reverberated on Nelson Street, across from the Newman family's (long-since-paved) cornfields. At sleepovers with my friend Dennis Field, I recall watching the cowboy show *Sugarfoot* and hanging out in the aging garage with scary tools owned by his father, a plumber.

On a recent afternoon, I summoned the nerve to knock on the door, even though the Fields by now are probably several owners removed. Luckily, no one answered. Better to preserve my old Cherrydale as a private memory—intact.

RECOVERING RIVERCREST

When I was twelve years old, I was a *Washington Post* paperboy, spending countless pre-dawn hours traipsing through my boyhood Arlington neighborhood of Rivercrest.

Each house, it seemed in the dark, had its own personality, traits I gleaned from making deliveries and returning once a month to collect fees (back when nearly everyone subscribed).

On Thanksgiving 2016, seeking a fresh route for my morning constitutional, I retraced that paper route. The result is my portrait of a Rivercrest frozen in amber, between 1961 and 1972.

This upscale subdivision marked on Military Road by curved "Rivercrest" signs is bordered by the lane heading down to Chain Bridge and Gulf Branch ("the creek," kids called it) with its adventure trail reaching the Potomac.

Rivercrest offers a quick commute downtown but no 7-11 within walking distance. (If you ran out of milk late at night, tough luck.) Housekeepers who came from the district took long bus rides. From the sidewalks, you can hear the traffic from the elevated George Washington Memorial Parkway. Noise from airplanes was steady enough that we got used to missing lines of TV dialogue. The Killhefer house had a mynah bird whose whistling pierced the Rivercrestian air.

Homes on these curved streets are mostly executive-style two-story and split-level spreads, many with columns and bay windows, some high on hills. They cost well over $1 million (my parents in 1961 paid $35,000).

I began my walk at the vacant lot near the road to Chain Bridge where architect Brockhurst Eustice in 1969 built a nonconforming narrow home. Neighbors filed suit, deeming it out of Rivercrest's character. The Virginia Supreme Court agreed; he tore it down.

The other "nonconforming" homes were Mrs. Wall's red-brick colonial that was smaller than her neighbors', and the Glovers' flat-roofed double-doored glass square, with zoysia grass. The Glovers owned Progressive Cleaners in Cherrydale. Other commercial names included the real estate families Yeonas and Gosnell, as well as the Levines, owners of Mario's Pizza. Politicos included Commonwealth's Attorney William Hassan, Arlington School Board member Lee Bean and attorney Dave Kinney, who in 1968 ran for Congress against unbeatable Joel Broyhill.

High on the hill of Thirty-Eighth Street lived Arlington county manager Bert Johnson, around the corner from Cliff Carter, top aide to President Lyndon Johnson. There was Watergate attorney Steve Shulman, noted air force general Jack Catton, Pentagon general counsel Len Neiderlehner and the ambassador from Botswana. Architect Jack Redinger engineered Ballston's recently demolished "Blue Goose" building.

Other neighbors included two CIA officials, a Federal Reserve staffer, a Commerce Department attorney, a World Bank big shot, a navy management

The nonconforming Rivercrest house was torn down. Yorktown Sentry.

consultant—and two dads with home offices. Another notable on my route but off in the neighboring subdivision of Arlingtonwood was broadcasting personality Willard Scott, half the radio team of "the Joyboys" who also played Bozo the clown and Ronald McDonald. (Scott, who later moved to Middleburg, Virginia, actually grew up in Alexandria, where he attended Maury Elementary School.)

Two moments of drama unfolded on steep Oakland Street. One morning, a dad at the top of the hill turned his car ignition on and returned to his house for coffee. The sedan rolled down and crashed into a utility pole in my front yard. No one was hurt. Similarly, the young Curry girl was once playing in her parents' parked car. She let loose the brake and, with Mom chasing after, sped screaming down across Nelson Street, where only a street sign, which she knocked over, prevented her from hurtling into the creek.

Today, you won't spot many *Washington Posts* on porch stoops. What I saw were numerous unreceived boxes of household goods and toys delivered, on a weekend, by a driver on behalf of Amazon.com. I wonder if he'll someday write about Rivercrest.

WHERE IS EAST FALLS CHURCH?

My adult Arlington neighborhood, called East Falls Church, throws off outsiders who assume that, with that name, it can't be part of Arlington. Indeed, our civic association a few years back took a vote on changing from the cumbersome Arlington–East Falls Church Civic Association to a simpler "Tuckahoe" or "Somerset." No go, said the prevailing traditionalists.

The confusion goes back to before the 1930s, when—as marked by our neighborhood sign emblazoned with a train car—East Falls Church split from Falls Church proper. It's one of many stories I savor that unfolded within walking distance from my home.

In the summer of 2015, an item in the *Sun-Gazette*'s history column reported that in August 1939, Tex Ritter and His Musical Tornadoes performed at the Lee Theatre. That emporium stood at the East Falls Church shopping strip, now a public storage at Lee Highway and I-66. Tex's visit was followed in the 1950s by country singer and sausage king Jimmy Dean, whose home stands at 1708 North Roosevelt. You want more historic houses? We got 'em.

The 1892 George Crossman farmhouse on Underwood merits a historic plaque for the still-inhabited structure built by our area's principal

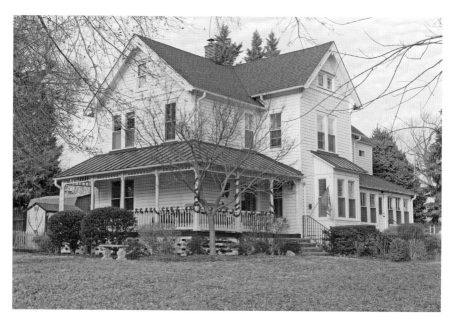

Nineteenth-century farmer George Crossman's home in East Falls Church. *Samantha Hunter.*

landowner in the later nineteenth century. Next to the BB&T Bank on Lee Highway is the 1876 Eastman-Fenwick house (which inspired a development of modern homes in the same Victorian style). Albert Eastman was an Army of the Potomac Civil War veteran (he defended Chain Bridge). In 1946, his granddaughter Eleanor moved into the house with her husband, state senator Charles Fenwick.

The beautiful green and mustard Victorian home built in 1889 at Washington Boulevard and Roosevelt Street is called the Fellows-McGrath House.

Our enclave's earliest landmark is the District of Columbia boundary stone on the site mapped out in 1791 by Benjamin Banneker. (His namesake park is at Eighteenth and Van Buren Streets.) But East Falls Church really came into its own in the 1890s, when army troops camped here for the Spanish-American War.

I'm indebted to former *Tax Analysts* writer John Iekel's research for details of the community's now vanished commercial ventures along the W&OD Railroad. Among them were the following: the nineteenth-century Thompson's grocery store, Ware's Pharmacy, Boyd's Fine Shoe Repair, the Eatwell Café, Call Carl auto repair and Snyder's Hardware (now a used car

lot). The *Northern Virginia Sun* and the *Virginia Democrat* once had offices near the strip, which was largely demolished in the 1960s to make way for I-66.

You can still taste the old neighborhood by strolling behind the East Falls Church Metro. Several higgledy-piggledy old wood-frame houses include extensions literally abutting the sidewalks—which would never pass modern setback codes.

The passions behind East Falls Church's secession are hard to grasp today. Talk surfaced in 1921, and articles in the *Washington Star* in the 1930s describe the Arlington Civic Federation offering water and sewer lines to Falls Church.

The neighborhood's gray zone created "an intolerable confusion of overlapping government agencies in this area," said Commonwealth's Attorney Lawrence Douglas. In 1932, citizens petitioned in U.S. Circuit Court to join Arlington. The Town of Falls Church complained that it would lose 60 percent of its business district and 30 percent of its land. The judge ruled for separation, which took effect at midnight on April 30, 1936.

The march of history continues. The entire East Falls Church Metro complex has been slated for new development—someday.

ABOUT THE AUTHOR

C harlie Clark is a longtime journalist in the Washington, D.C. area who writes the weekly "Our Man in Arlington" column for the *Falls Church News-Press*. By day, he is a senior correspondent for Government Executive Media Group, part of Atlantic Media. He previously worked as an editor or writer for the *Washington Post*, *Congressional Quarterly*, *National Journal*, Time-Life Books, Tax Analysts and the Association of Governing Boards of Universities and Colleges. His 2013 book *Arlington County Chronicles* received the Arlington Historical Society's Cornelia B. Rose Award in 2015. He lives in Arlington with his wife, Ellen.